D1503228

THE ART OF
WILDLIFE
PHOTOGRAPHY

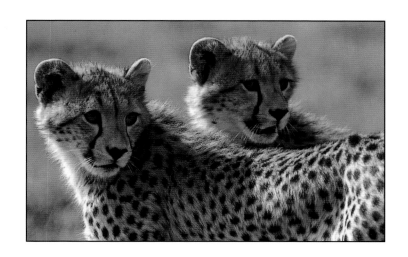

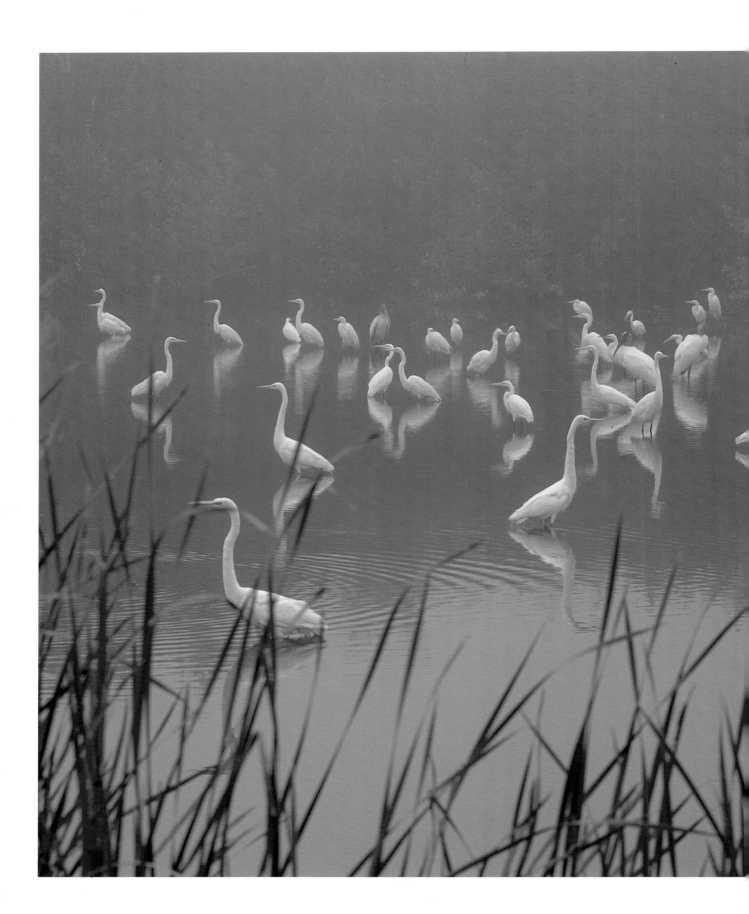

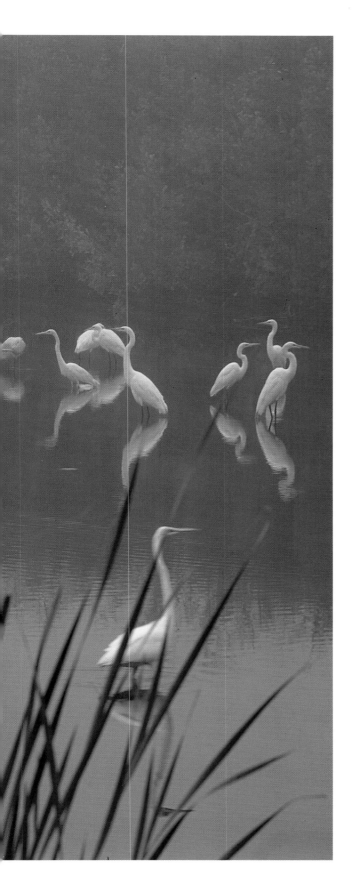

THE ART OF
WILDLIFE
PHOTOGRAPHY

Fritz Pölking

FOUNTAIN PRESS

Published by
Fountain Press Limited
Fountain House
2 Gladstone Road
Kingston-upon-Thames
Surrey KT1 3HD

All rights reserved
No part of this book may be
reproduced in any form or
by any means without
the permission of
Fountain Press Ltd.

Text Edited by
Graham Saxby

Designed by
Grant Bradford

Page Planning
Rex Carr

Additional Colour
Reproduction
Supreme Publishing
Services

Printed in
Hong Kong

Title of the German edition
Naturfotografie
Augustus Verlag, Augsburg
© 1995 Weltbild Verlag GmbH,
Augsburg
English language edition
© Fountain Press 1998

ISBN 0 86343 322 7

CONTENTS

INTRODUCTION

This is a marvellous time for photography. Never before has there been such a variety of cameras, lenses and films, nor of such high quality. For amateur nature photographers there has never been so much spare time in which to indulge their hobby. It is easier, too, for amateur and professional alike to reach remote and beautiful locations quickly and cheaply. For a nature photographer it is certainly a great time to be alive.

This book is aimed at helping you to discover the fascinating world of nature photography, or, if you are already familiar with it, to show you new routes, locations and field techniques, for a more satisfying and comfortable experience. This book is written from a subjective point of view. It is based on some forty years of experience as a nature photographer. Consequently, you won't find generalised statements about equipment and techniques. Instead I will tell you, for example, which tripod suits me best, and why this is so. Of course there are plenty of other perfectly good tripods, but I feel this approach will be helpful to you when it comes to the selection of your own equipment. My choices are the result of long experience, and they certainly work for me!

Although I hope you will be helped by this book, there will no doubt be opinions you will disagree with. But I believe it is better to be positive about what works for me than to make vague suggestions as to what might (or might not) work for you.

However, the best advice I can give you does not relate to the technical aspects of the equipment, it is that you should learn as much as possible about your subject matter: the animals, the plants, the whole environment. To know the characteristics of your subjects, whether animal behaviour or favoured plant locations will allow you to make the most of your time in the field.

But there is also a wider aspect. A knowledge of flora and fauna not only makes you a better nature photographer: it is good news for the whole world of nature. Such knowledge encourages people to treat all life forms with respect. It leads to a deeper appreciation of life itself. You find you are making a special effort not to disturb animals, trample or uproot plants, or manipulate settings in the interest of composition. Indeed, conservation of wildlife and plants has become the policy of all developed and developing countries, and in most of them there are strict laws forbidding the disturbance of rare or endangered species.

Always treat Nature with the respect she deserves. Life in nature depends on a delicate balance between the needs of animals and plants and their environment. In most countries the law is specific: you may not disturb any wildlife or damage any sites of plant life that are on the endangered list in the process of photographing or filming them, or conducting similar activities. This doesn't mean that photography of endangered species is forbidden, merely that you mustn't disturb them in the process.

Such restrictions can make nature photography difficult: we can't always get the picture we want. It may, for example, be difficult to photograph a sea eagle or an owl in their isolated nests without disturbing them. A blue tit or a robin is another matter. Such birds even seek out human company. The trouble is that it is often difficult to say what the limitations are with each individual species. There are also situations which confuse the issue, for example if you cannot get a photograph of a comparatively common species without disturbing another species.

Nature photographers in general consider themselves to be environmental conservationists, and do stick to the rules. Those who do disturb their subjects quickly get a bad name among the photographic fraternity. Remember, some species may be common in some areas but rare in others. The bee-eater is a rare visitor to northern Europe but is common in southern Spain; in Scotland osprey nests are even protected by patrols, but in Florida they are abundant and almost tame. The golden rule is: treat all animal and plant life as you yourself would wish to be treated.

Nature photography has a purpose beyond simple documentation. It is also a form of artistic expression. It combines factual recording with creative art, and thus helps to reconcile our technically-based society with the natural world. Nature photography is like hunting with a camera, striving to get the best possible shot of a particular animal or plant or landscape. It can also be an aesthetic experience – an opportunity for self-realisation that is not otherwise available to us in the modern world. Indeed, nature photography can serve as a refuge from the stresses of daily routine, as well as being a personally rewarding activity.

But just what is 'nature photography'? Well, it can be different things to different people. For myself, it is the opportunity to express my feelings about the natural world, through photography. It is these feelings that compel me to go out and capture their representation in pictures – partly, I admit, in order to share them with others. Photography can become more than just a sublimation of the hunting instinct, or a search for the perfect composition. It can share with others the deeper and more meaningful concepts of nature.

Such visionary objectives in nature photography place our medium on the same level as fine arts such as painting, music and literature. We express our images of the natural world through our photography. Nature photography thus becomes art. Such a level of expression is not easily attained, nor can every photographer expect to attain it. You don't have to try to make every Picture a work of art. But you do need to be familiar with the basic aesthetic elements, as well as the technicalities of your equipment.

Images of nature appeal directly to our instincts. But sometimes I ask myself

whether our photographs do reflect reality. Or are we just taking a carefully chosen slice of time in order to confirm our expectations of the natural world? Are we photographing nature in lieu of experiencing it? or, on the other hand, do we experience nature more intensely through photography, and would we experience it at all without photography? Is everything in nature without interest unless it can be photographed?

We live in an artificial world. Perhaps nature photography is a link to a more authentic existence, bringing us close to life in the natural settings that were once ours. Certainly, from my own experience nature photography can teach us plenty about life.

I would be very happy if I could help you on your way to the world of nature photography through this book. There are pitfalls on the journey, but there are also summits of achievement. The farther you go, the clearer those summits become. They are the true rewards of nature photography. I wish you a long and pleasant journey into this fascinating world, and a triumphant entry in your logbook when you reach your first summit.

Sincerely,

Fritz Pölking

Note: All the nature photographs in the text were taken using a tripod unless otherwise stated in the caption.

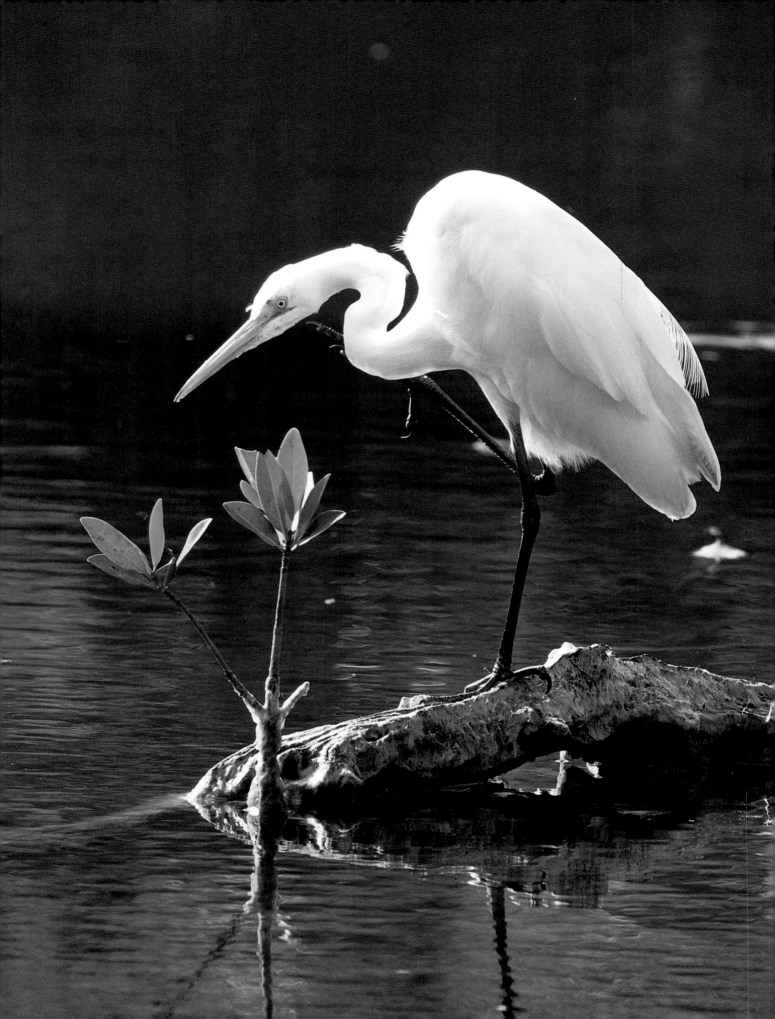

CAMERAS & LENSES

Cameras are tools. They are the means to an end; they are important, but one should not worry too much about them.

Frans Lanting

The 35mm SLR camera

The decision as to which equipment to use in nature photography begins with the selection of a camera and its lenses. Selection of the camera involves, first, a choice between the various types and film for at available. Do you want a rangefinder camera, a view camera or a single-lens reflex (SLR)? and shall it be 35mm, medium format or large format?

If you are not interested in calendar, poster or other large work, or specialised high-speed photography, my advice is to go for a 35mm SLR camera with interchangeable lenses. For general work there is no real alternative: the vast majority of all wildlife and nature photographs which appear in magazines are made with just such equipment. Although medium and large format cameras offer the advantage of a larger film area, today's 35mm SLR cameras have practical advantages, especially for photographing moving animals or dealing with varying light conditions. The modern 35mm SLR has features such as high-speed motor drives and fast autofocus, as well as highly accurate metering modes. In addition, the most recent films are far superior to those of even a few years ago. 35mm slides can now be electronically scanned and printed to a level of excellence comparable with the best colour prints.

Great Egret, Sanibel Island, Florida, USA.

A further important reason for choosing an SLR camera is its speed of operation, which allows you to capture that special moment, to record on film a fleeting event which represents so much more than the recording of a subject in sharp focus.

Which SLR system?

Once you have decided to use a 35mm SLR camera, the next choice is more difficult: which camera should you choose? Today, Canon, Contax, Leica, Minolta, Nikon and Pentax represent the available choices. 95 per cent of the pictures in this book were taken using the Nikon F-4, at the time of its introduction possibly the most advanced of all professional SLRs, and now being superseded by the even more advanced F-5. A few were taken with its immediate predecessor the F-3 or with my back-up camera the Nikon 8008 (F-801). But I could just as well have taken nearly all of them with a Canon or a Minolta, or, indeed, almost any other system. Which system one finally chooses is largely subjective, like choosing a car. You simply choose the car which will make driving most pleasurable. So base your choice of a camera on whether it has the features you need both for now and in the foreseeable future.

Whichever camera you choose, there are important aspects you should consider. If you prefer manual operation, make sure the shutter speeds and f-numbers are easily readable, as you will be constantly looking at these values, possibly in poor light. If your tastes lean towards landscapes or close-ups, you need a camera with a 'preview' button. If you use long exposure times or work with long-focus lenses, a mirror lock-up function will be essential. And if you use a cable release regularly, make sure the viewfinder has an optional blind built in, to prevent stray light from entering the rear of the viewfinder.

(All these points are discussed later.)

Do you already have an appropriate system? If so, stick to it! But if you are a newcomer to nature photography, or if you feel you need a change, or are thinking of upgrading your equipment, Canon and Nikon have the most to offer to outdoor photographers, closely followed by Minolta and Pentax. Let me explain, by taking the important features in turn.

Important features
Preview Button

A preview button allows you to close down the iris diaphragm to your chosen aperture setting before you make the exposure, so that you can see directly the depth of field, or zone of sharp focus, produced by that aperture. Closing down the aperture (i.e., increasing the f-number) increases the depth of field but decreases the amount of light reaching the film. Conversely, opening up the aperture increases the amount of light and decreases the depth of field. Surprisingly, some makes of SLR, Minolta for example, omit this (to my mind) essential mechanism.

The preview button is important for landscape work and essential for close-ups, because these are situations where the depth of field is a vital part of the composition. You need to see exactly what will be recorded before you make the exposure. Normally, when you look through the viewfinder you will see only the depth of field given by the lens at full aperture. This is order to give the brightest possible image, for accurate focusing. But this tells you nothing about the zone of sharp focus you will get at your chosen f-number. This can be very misleading, particularly if you wish the background to be out of focus, say, or the foreground to appear pin-sharp.

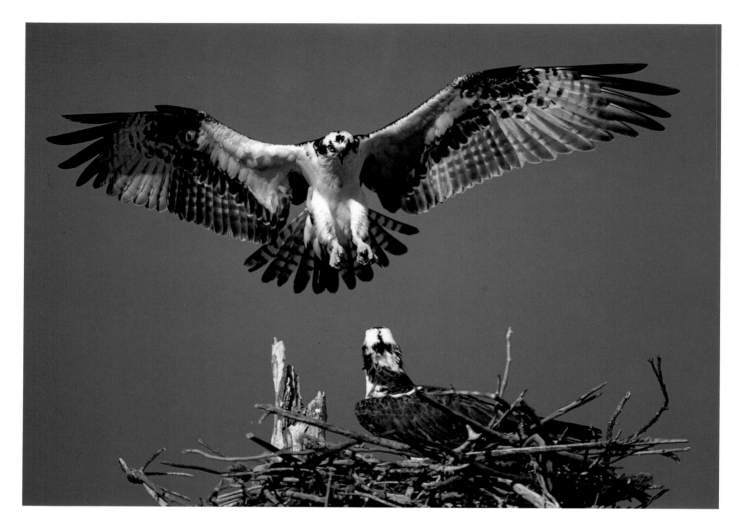

The depth of field is greater behind the focusing point than in front of it, except in extreme close-ups (1:1 scale or greater). For landscapes, for example, using an aperture of f/8 with a 28mm lens you can focus on a distance of 1.3m (4ft), and everything will appear sharp from 0.65m (25in) to infinity. (Many photographers adopt a rule of thumb that says the depth of field behind the subject is twice that in front of it – but this applies only to focused distances of around 3m for a 50mm lens, for example.)

The relationship between exposure time and aperture setting is governed by the law of reciprocity, which states that exposure = intensity of illumination (at the film) X duration of exposure. Thus for a given exposure, if you decide to close down the aperture two stops (say from f/8 to f/16) you must compensate by increasing the exposure time by two 'stops' (e.g. from 1/60s to 1/15s). This raises the problem of the subject moving during the exposure and blurring the image. For this reason you

should always use the largest aperture that will give you adequate depth of field.

Getting the depth of field right is vital in close-up work. It has to be sufficient to allow all parts of the subject matter to appear sharp. But it shouldn't bring the background into anything like sharp focus as this would be distracting. It is a delicate balancing act to find the f-number for which the main subject is fully sharp, while the background does not show any recognisable form. Here is an infallible way to get the zone of sharp focus exactly right in a static subject:

1 Cut out the autofocus facility if you have one, and make sure the automatic exposure control is set to aperture priority.
2 Focus on the farthest part of the subject that you want to appear sharp. Check the distance setting on the lens barrel.
3 Focus on the farthest part of the subject that you want to appear sharp. Check the distance setting.

Female osprey approaching nest.
Captiva Island, Florida, USA.
600mm f/4 lens, Fujichrome 100.

4 Set the focus so that the two settings are an equal distance either side of the focus indicator line on the lens barrel.
5 Check the f-number indications on the depth-of-field scale on the lens barrel. They should be the same either side.
6 Set this aperture. (It may be between two marked stops.)
7 Check with your preview button, if you have one.

This sounds long-winded, but in practice it doesn't take more than a few seconds. It is absolutely essential in extreme close-ups such as small flowers.

A preview button is not important in wildlife photography, as in action situations one works at full aperture. This allows you to use the highest possible shutter speed, to eliminate camera shake (which is more serious with long-focus lenses) or blurring due to subject movement. The shallow

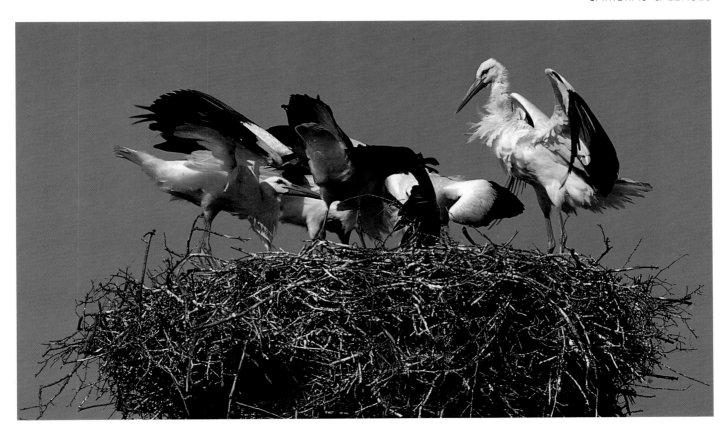

depth throws the background out of focus while the subject appears sharp, giving a better sense of perspective.

Mirror lock-up

At the moment of exposure the camera should be absolutely still. But the mechanism of an SLR camera seems to have been designed to prevent this! When you press the shutter release the autofocus (if you have one) jerks the lens into the focused position, then the iris diaphragm closes down, the mirror slaps up and the leading shutter blind slams open, all in a fraction of a second, closely followed by the trailing blind closing the exposure. All this takes place in jerks; and to it can be added any unsteadiness of the photographer's hands!

The vibrations caused in particular by mirror slap are particularly noticeable where exposure times are between 1/15 and ¼ s. With higher shutter speeds the effect is lessened by the short exposure time. With longer times, say 2 s or more, because shutter slap occurs only at the very beginning of the exposure time, its influence is reduced. If you are taking a picture at an aperture of, say, f/22 and an exposure time of 4 s, you don't need a

mirror lock-up. So if your camera doesn't have one, keep away from shutter speeds of between 1/15 and ¼ s, especially with long-focus lenses.

In my experience mirror slap is not important with a 105 mm f/2.8 macro lens, for instance, provided the camera is mounted on a solid tripod with a large ball or tilt lever head. Nevertheless, a mirror lock-up function is so important for nature photographers that I should like to see a camera appear on the market with the option to automatically raise the mirror one second before the actual exposure. In fact, at the time of writing there are only a few cameras available that have mirror lock-up, notably the later Nikon and Canon models and the Leica R6. Some older SLR models have a mirror that is raised automatically when the self-timer is in operation, but this doesn't happen with the newer models.

Viewfinder blinds

The advanced features of today's 35 mm SLR cameras make it so easy to take pictures hand-held that many photographers don't bother to use tripods or cable releases, regarding such accessories as passé. They are seriously mistaken, of course. However, the use of

White stork and young on nest; Bergenhusen, Germany. This species of stork is on the endangered list, but long range nature photography doesn't pose a threat. 500 mm f/4 lens, Fujichrome 50.

a tripod with an SLR does bring another hazard when making longer exposures, namely the entry of stray light through the viewfinder, which can affect the exposure metering system. This applies to most SLR cameras, exceptions being the Olympus OM-2 and OM-4, where the meter reading is taken off the film plane after the mirror is raised. In hand-held photography there is no problem as your head blocks the light. But when photographing landscapes or close-ups and using a remote shutter release, one is not right behind the camera but apart from it, waiting for a cloud to clear the sun, or for the wind to die down. This is when stray light entering the viewfinder aperture is likely to result in an underexposure of anything from ½ to 2 stops.

To test your own SLR camera for sensitivity to stray light, mount the camera on a tripod in the late afternoon with the sun behind it, look through the viewfinder and check the meter reading. Now move your head away from the eyepiece just

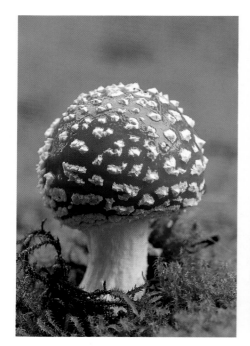

Fly agaric, almost life size. Bayerischer Wald National Park. 200 mm f/4 lens, Fujichrome 50.

enough to let the sunlight enter it and recheck the meter reading. If the meter now indicates a smaller exposure, it is being affected by the stray light, and you will have to use the viewfinder blind during long exposures. If your camera doesn't have a viewfinder blind you will have to buy or make a little lens cap to fit over the eyepiece.

Exposure control

The camera is a tool. It should not only do its work in a way that allows you to concentrate on the work in hand, that is, to compose your scene and photograph it, but should also feel comfortable in your hands, and not distract you from the task of getting your shot.

One important part of the camera's functions is the control of exposure. In a manually-controlled exposure both the aperture setting and the shutter speed are set by the photographer in accordance with the reading from a meter (built in or hand held). In automatic metering these functions are handled by the camera. However, there needs to be some method of overriding the automatic control for out-of-the-ordinary lighting or subject matter, or for special effects.

Today there a wide variety of options for setting a camera so that it will control the exposure, even within the same family of cameras from a single manufacturer. The Nikon F-4 and F-5, for example, allow

deviations of exposure of up to two stops in steps of $^1/_3$ stop in automatic exposure modes, simply by turning a dial on the top of the camera. This can be done very fast, and is useful in wildlife photography. In earlier Nikon models one has to push a button and then turn a dial, which slows the operation somewhat. The new Nikon N-50 (F-50), on the other hand, requires four steps to reach $+^1/_2$ or +1 in the shutter-priority mode, which is not at all helpful to a photographer needing to concentrate on the subject matter.

There are other points to consider, especially in the case of manual exposure control. Some camera models don't display aperture values or shutter speed settings in the viewfinder when set on 'manual', but display '0.0' or some similarly unhelpful symbol when the exposure is 'correct'. This is less than satisfactory: anyone exposing manually deserves fully-labelled shutter and aperture controls, and preferably a display in the finder too.

To summarise: it is very important to look at all the functions and visual displays of a camera before you buy it, and to make sure it meets all your individual needs. Are all the numbers and symbols in the viewfinder easily readable, even when you are wearing glasses? How bright and clear is the viewfinder image? Is there a mirror lock-up function? Is there a viewfinder blind? Is information about the different functions displayed in a way useful to you? Are the buttons, dials and knobs on the

camera all within easy reach and simple to use? Can you still use them in the dark, or if your fingers are numb, or if you are wearing gloves? And is it easy to get the camera repaired if it is damaged? If the answer to all these questions is 'yes', you will have found the right tool for the job.

Lenses: fixed focal length or zoom?

Opinion is divided among photographers (including nature photographers) on the rival merits of fixed focal length and zoom lenses. What is inarguable is that the best zoom lenses are heavier, slower and inferior in optical quality compared with the best fixed focal length lenses. Of course, a top-class zoom will give better results than a cheap fixed focal length lens. But a fixed focal length lens with as few as five elements can be very well corrected, whereas with as many as eighteen elements a zoom lens still has to compromise by averaging its corrections over its range of focal lengths. The ultimate question is whether you can tell the difference in the final picture. When I mix an assortment of nature slides on a viewing table and invite photographers to tell me which were made with a zoom lens and which with a fixed focal length, nobody

Young cheetah and flying safari ants, Masai Mara, Kenya. Nikon F4, 300mm f/4 lens, Fujichrome Velvia 50.

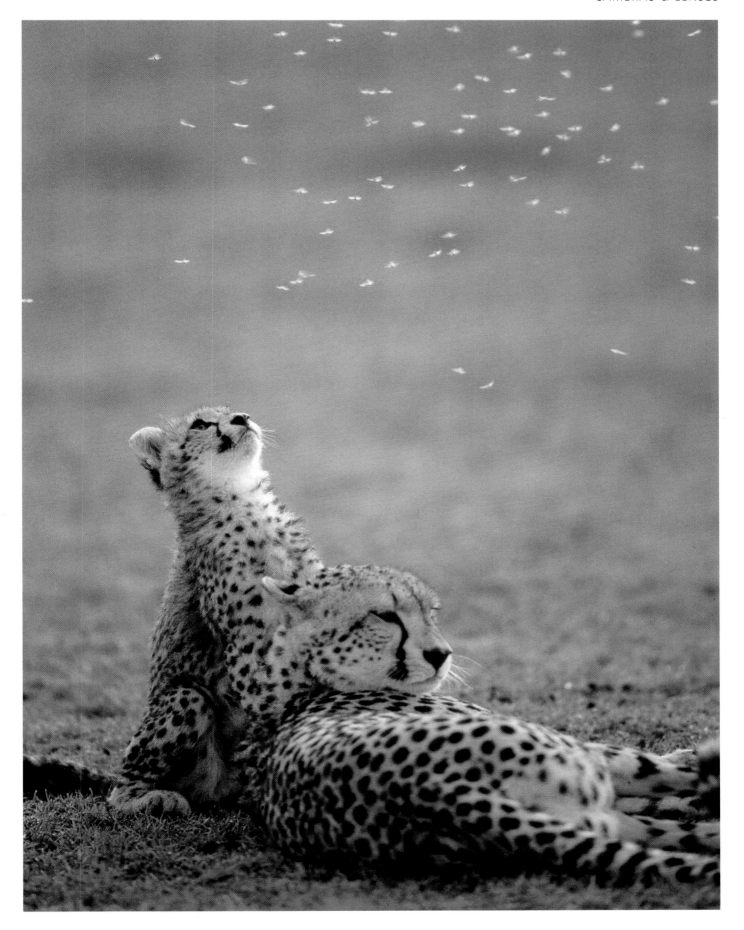

can tell. Only in photographs with many vertical straight lines (such as a conifer forest) is the difference detectable: all zoom lenses show some distortion at their extreme settings, showing outward curvature (barrel distortion) at the shortest focal length and inward distortion (pincushion distortion) at the longest focal length.

My own choice is a simple one. Whenever possible, I use a fixed focal length lens. Only if I feel a picture could be improved by using a zoom do I fit one. I own and regularly use the following lenses for nature photography. For close-ups I use a 55 mm f/2.8, a 105 mm f/2.8 and a 200 mm f/4, all fixed focal length macro lenses. That they are not zooms is unimportant as I can easily change the framing by sliding the camera towards or away from the subject. For landscapes I use a 20 mm f/2.8 and a 24 mm f/2.8 and 28–85 mm and 80–200 mm zooms. I have found these seven manual-focus (MF) lenses excellent for close-up and landscape work, and I haven't found any need for autofocus capability. My only two autofocus (AF) lenses are telephotos employed for wildlife photography, namely a 300 mm f/4 and a 500 mm f/4. (The uses of all these lenses are described in detail later.) Were one available, a 200–500 mm AF tele-zoom would be most acceptable.

Autofocus or manual focus?

When choosing between an AF and a MF lens you should remember that you can use an AF lens in MF mode when there is a need to focus manually. However, in my experience when AF lenses are used in MF mode the 'feel' of the focusing mechanism is not good. In fact, I sometimes have the impression that manufacturers find it a nuisance to have to build manual focusing into their lenses, so it tends to be treated as a secondary function. Often the MF function has literally no feel to it, and the focus range is minimal. (This may be because the AF mechanism operates best when the lens has only a small distance to travel.) Greater care seems to have been taken with the more expensive AF lenses; but none of the AF lenses seems to give you the authentic feel of focusing that you get with a true MF lens.

Is an AF lens really necessary in nature photography? This is not an easy question to answer. With some camera systems you have no choice (e.g. the Canon EOS and Minolta Maxxum models). In my view, for landscapes and close-ups an AF lens is more trouble than it is worth. These types of picture are best made using a tripod, carefully composing the picture: there is no advantage to be gained from using AF. If, on the other hand, your subject is moving and you need to follow-focus fast,

Above: Fern, Audubon Cork Screw Swamp Wildlife Sanctuary, Florida, USA. I waited over an hour before the light was just right. There is no substitute for patience. When the sun finally peeped out between two clouds, everything had to happen fast.

Here, a camera that is quick and easy to handle is needed. 300 mm f/4 lens with X1.4 teleconverter. Kodachrome 64 pneumatic release.

Top: Approaching mute swans, Baltic Sea near Burg on the Isle of Fehmarn. An earlier image from my photographic stone age. As you can see, it is possible to take sharp inflight images without AF, but the success rate is much less than with it. Nikon F3, 400 mm f/5.6 lens, Kodachrome 64, hand-held.

Bottom: A lioness and her cub. Masai Mara, Kenya. A tender scene which looks as if it could be done with manual focusing. Not so. I would never have got this shot if I had had to take the time to focus. I would have had less than one second to focus – not enough for a very long – focus lens. As it was, I was able to take three shots in less than a second using the motor drive, and all were sharp. 600 mm f/4 AF lens, Fujichrome 50, car window support.

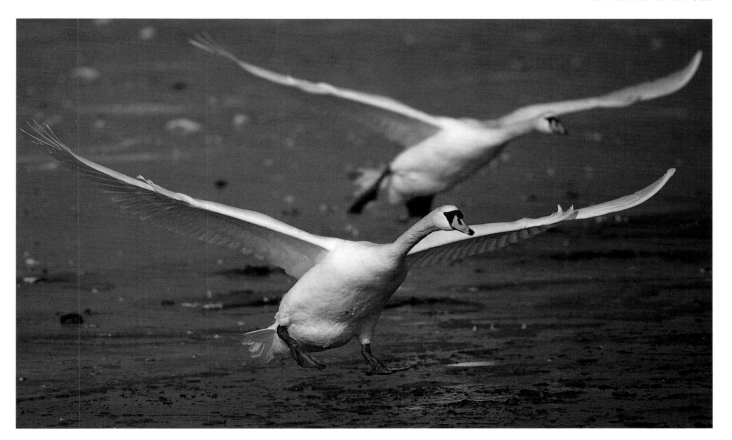

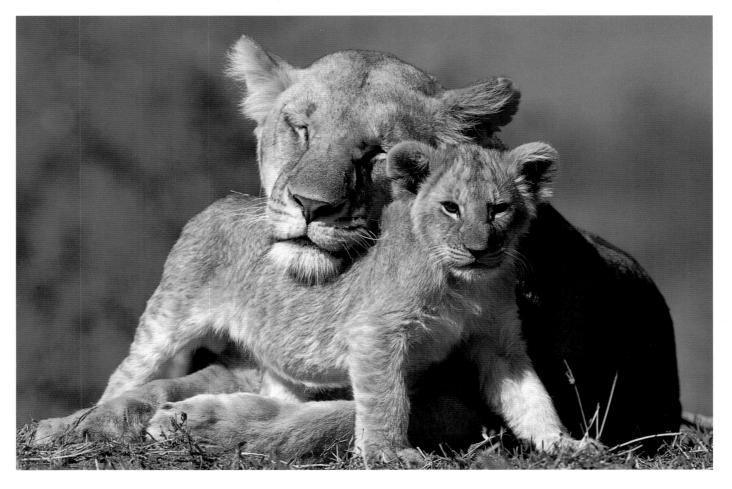

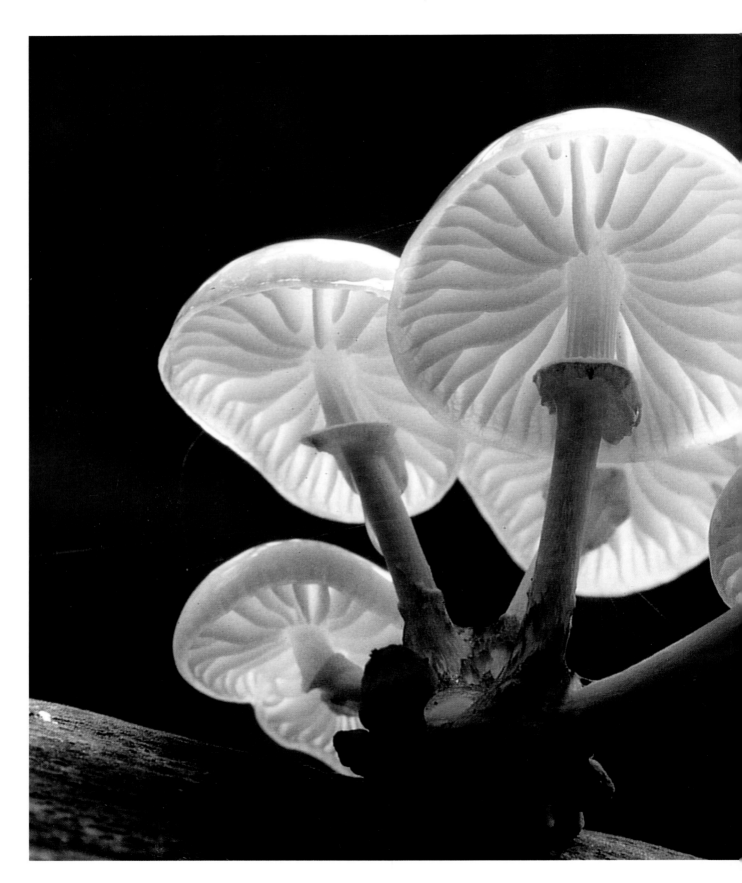

then AF is unbeatable. Nobody can focus manually as quickly and accurately as a modern AF system can, especially when the animal is constantly changing direction. But the key question is: how often is that kind of speed really needed? While in Germany I have never made a photograph using an AF lens, even though I shoot about 500 to 1,000 rolls a year. But when I go to East Africa, where I take at least half of my pictures, I photograph wildlife exclusively with AF lenses. Maybe it is because in Africa I nearly always operate from a vehicle, and I can do so much faster with an AF lens. Incidentally, when photographing running animals or birds in flight, my advice is not to switch to autofocus while the subject is still small in the viewfinder. Unless it is very well centred it will be lost and the lens will now home in on infinity, thereafter taking critical seconds to get back on track.

I strongly recommend AF lenses for action shots of wildlife. If you are using a Canon or a Minolta system, all your lenses will have to be AF, with switchable MF mode. If you prefer Nikon or Pentax you have the option to get MF-only lenses for landscapes and close-ups and AF lenses for your action work. Leica has an all-MF lens system. Or you can buy a good-quality second-hand camera such as a Nikon F-2 or F-3. The most recent Contax SLR cameras have an AF system built into the camera body, so you can use them with all the Contax MF range. When deciding between AF and MF, however, keep in mind that there is no difference in the optical performance of the two types of lens.

Porcelain or 'poached egg' fungus.
Bayerischer Wald National Park.
100 mm f/2.8 lens, Fujichrome 50.

WIDE-ANGLE LENSES

20mm f/2.8

Superwide-angle lenses such as this are tricky to work with because their field of view includes – almost everything! They have an astonishingly large depth of field even at full aperture, but they also produce seriously converging verticals when tilted up or down only slightly, and they distort the proportions of the subject. However, many mature photographers reach for a superwide for just these reasons. These lenses can, indeed, give a rather ordinary scene a dramatic rendering because of the large angle of view and the way they make the foreground stand out.

In nature photography a superwide-angle lens tends to be used for one of three reasons: first, when you can't otherwise get all the subject matter in, because you can't get far enough away from it; secondly, to change the relationship between foreground and background in favour of the former; and thirdly, since a superwide enlarges anything in the foreground, to emphasise a part of the scene, as for example in the picture of the ferns in the wood. This near-vertical shot was needed for a book about forests. I waited for cloudy weather, as the dappled sunlight that is typical of fine weather in woodland areas makes good pictures of this type impossible because of the excessive contrast. When I finally came upon this area of lady fern, I tried several different focal lengths and camera positions to find an interesting image which would be botanically correct and would not appear to have been distorted for effect. The 20mm lens proved to give the best compromise.

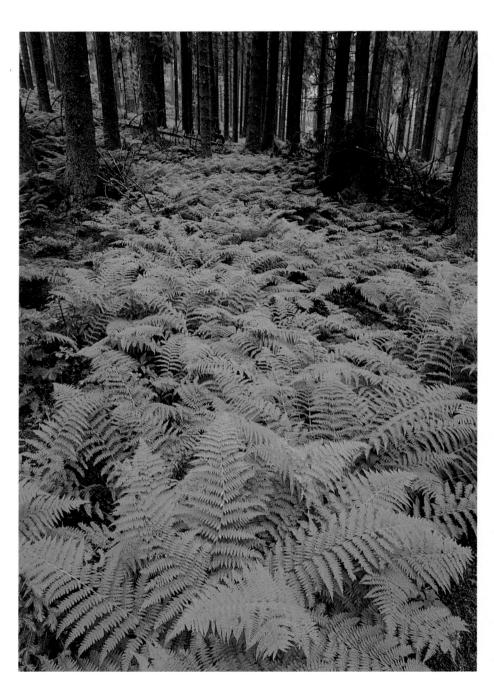

Lady fern, Bayerischer Wald National Park.
20mm f/2.8 lens, Fujichrome 50,
pneumatic release.

24mm f/2.8 lens

When it comes to working with short-focus lenses, the 24mm rates much higher in my book than the 20mm. I only take the latter one along with me when I travel to my destination by car. When I have to backpack with my camera gear the 20mm lens is invariably left behind. For every subject I might shoot with the 20mm lens there are at least twenty for which I would prefer the 24mm. Its slightly smaller angle of view gives a more balanced treatment of the scene, rendering the surroundings in better proportion. 24mm is my favourite focal length for landscape photography, and I use a fixed focal length MF version. I often add a polarising filter when shooting landscapes, as it increases the colour saturation and intensifies the colour of the sky. The Olympic National Park landscape is a good example of the balanced perspective possible with this focal length. A 20mm lens would have exaggerated the size of the daisies in the foreground and diminished the mountains in the background.

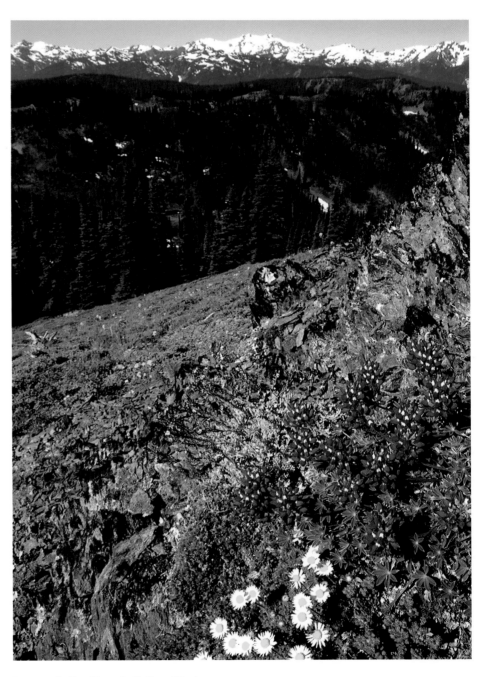

Summer in the Olympic National Park, Washington, USA. 24mm f/2.8 lens, Fujichrome Sensia 100 pneumatic release.

ZOOM LENSES

35–70 mm and 28–80 mm zoom lenses

Zoom lenses which cover the medium focal lengths are common today and come in a wide variety of designs. They range from slow, lightweight, inexpensive models to fast (f/2.8) lenses using special low-dispersion optical glasses. If you do a lot of landscape photography, especially with a polarising filter, you would do well to consider one of the faster lenses since they supply a reasonably bright viewfinder image with a polarising filter in place. I always take a small lightweight 35–70 mm f/3.5–4.5 on my northern trips as I don't relish dragging a large, heavy lens across tundra.

I shoot most of my landscapes with the 24 mm f/2.8. the 55 mm f/2.8 macro or the 80–200 mm f/4 zoom. Only rarely do I reach for the smaller zoom. But when I travel to areas where the variation in scenery is the main attraction. I rely heavily on a medium zoom lens, and here my preference is for the 28–85 mm zoom.

The quality of image produced by moderate range zooms such as the 35–70 mm or 28–85 mm lenses is not a big concern of mine, as I only use them for landscapes and work at around f/16 or f/22. Almost any good-quality lens works fine at these small apertures.

When a zoom lens is designed to cover a very wide range of focal length it is far more difficult to design a high-quality lens. This is especially the case when the zoom range includes extreme wide angle or extreme long focus. Although many zooms with a focal length ratio of 2:1 or 3:1 are well made and give good results, it takes a great deal of effort and expenditure to design and build a high-quality zoom with a ratio of 5:1 or 10:1. Such lenses may cost more than the camera on which they are being used.

Marguerites in the Bavarian Forest. 28–70mm f/3.5 zoom lens, Fujichrome Velvia 50 (exposed as ISO 40) pneumatic release.

70–210 mm and 80–200 mm telephoto zoom lenses

In this longer focal length range there are again many models to choose from, including the popular 70–210 mm range with a variable aperture of f/4.5–5.6, as well as a few good zooms with a fixed maximum aperture of f/4 or f/4.5, and some top-quality heavy and expensive zooms in the 70–210 mm f/2.8 or 80–200 mm f/2.8 ranges. These latter so-called professional lenses all come with a tripod collar, except for the Nikon models.

For wildlife photography in Africa I use the AF 70–210 mm f/2.8 by Sigma, which has a tripod collar and an internal focusing mechanism in which the front of the lens barrel doesn't rotate when being focused. This is particularly helpful when I see a polarising filter or a graduated neutral density which, once set up, must not be rotated during focusing. For shooting elsewhere in the world, I would rather use the old Nikkor 80–200 mm f/4 MF lens, pressing it into service for wildlife (occasionally), landscapes (often) and for close-ups when I don't fell like carrying a 200 mm macro in my backpack.

While all these choices are a matter of personal preference, I would caution you not to expect too much of the cheaper, slower zoom models. I suggest weighing the choices that are available among the f/2.8 and f/4 models. As a general rule, each additional stop of speed doubles the cost and more than doubles the weight of a zoom lens. Although the f/2.8 lenses are much heavier, they do have the advantage of a tripod collar, so it is easy to change your format from a landscape to a portrait format, and vice versa. It also means that the camera is supported at its centre of balance. I have found two characteristics among the zoom lenses in this category: almost all the lenses I have tested render the slides somewhat lighter than expected when they are stopped down. So if you want the same slide density at f/8 or f/11 as at f/2.8, you will probably need to use an exposure correction of at least l stop. Also, it is worth checking when purchasing an MF zoom lens that, when focusing at 200 mm and then zooming back to 80 mm, that the lens maintains accurate focus and you don't have to manually re-focus.

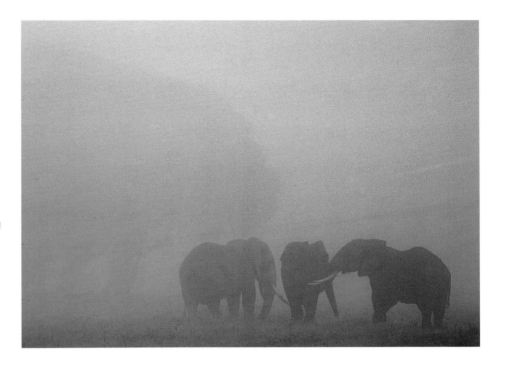

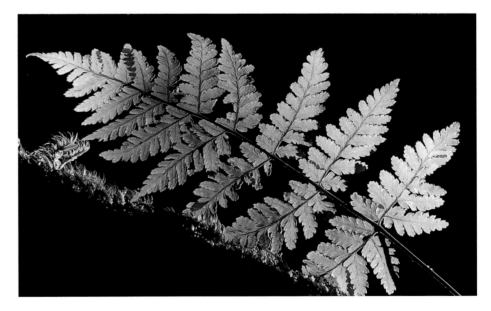

Top: Elephants in morning fog in the Ngorongoro Crater, Tanzania. 80–200 mm f/4 zoom lens, Kodachrome 64, car window support.

Bottom: Backlit fern in the Bayerischer Wald Nature Park. 80–200 mm f/4 zoom lens, Kodachrome 25.

MACRO LENSES

55mm f/2.8 macro

One of the reasons I don't use a zoom lens that covers the medium range of focal lengths very often is that I own a 55mm f/2.8 macro lens. With the arrival of AF zoom lenses some sections of the photo industry seem to have abandoned manufacture of mechanically detailed, finely crafted lens mounts in favour of synthetic materials that bear little resemblance to metal, and take away much of the pleasure of photography. It wouldn't surprise me if these tacky products bore a large share of the reason for former enthusiasts losing their interest in photography and taking up stamp-collecting or playing with computers. Today, as a group, manually-focused 50mm or 55mm macro lenses are still 'real' lenses in their construction, and can be used for just about any situation from landscapes to documentation – and, of course for their intended purpose, photomacrography. The 50–55mm focal length gives a natural rendering of general subjects, more natural than a medium-long-focus lens such as a 105mm, which tends to isolate the subject from its background.

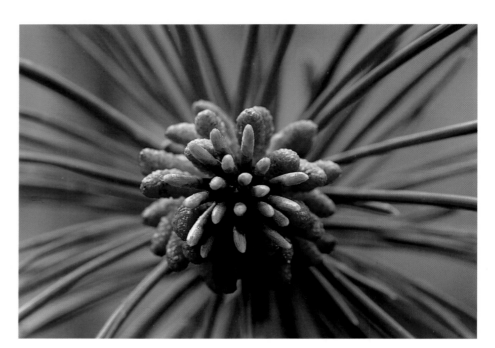

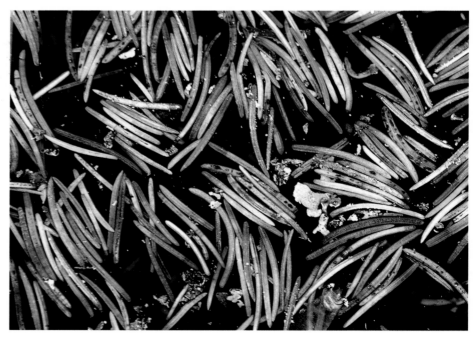

Top: Scotch pine; male inflorescence and new spring growth. (X2). Bayerischer Wald Nature Park. 55mm f/2.8 macro lens, Fujichrome Velvia 50 (exposed as ISO 40) pneumatic release.

Bottom: Spruce needles in swamp water. Bayerischer Wald Nature Park. 55mm f/2.8 macro lens, Fujichrome 50 pneumatic release.

105 mm f/2.8 macro

This is my bread-and-butter lens for close-up photography. In fact, if I had to choose only three fixed focal length lenses for all my work they would be this lens, along with the 28 mm f/2.8 and a 400 mm telephoto. At f/2.8 this 105 mm lens has a wide aperture giving a bright viewfinder image, and produces a suitably restricted zone of focus when used at full aperture. This makes it easy to focus when working close up with a subject such as a mushroom or a leaf. At the same time, this greater focal length allows a comfortable working distance from the subject, even at high magnifications. Most of the 105 mm macros allow a 1:1 (life-size) ratio, either by themselves or with an extension tube.

One could take the same close-up pictures with a 55 mm macro, but apart from the more comfortable working distance of the 105 mm, the longer focal length of the 105 mm gives a better representation of the background. Thus, whereas I might shoot a flower from a distance of 10 cm with a 55 mm lens, it would be 20 cm with a 105 mm lens, with the subject looking much the same in both pictures. with the shorter focal length, however, I get a wider angle of view, and therefore a greater proportion of background in the picture than with the 105 mm.

Termite wings shed after their wedding flight. The termites swarmed the evening before, after a long heavy rain; the next morning the savannah was covered with wings, in some places 10 mm deep. Masai Mara, Kenya, December. 105 mm f/2.8 macro lens, Fujichrome 50 pneumatic release.

200mm f/4 macro

Another possible triple combination of useful lenses would be a 24mm f/2.8 for landscapes, a 500mm f/4 for wildlife and a 200mm f/4 for plants and butterflies. I prefer to work with the 200mm macro rather than the other macros for three reasons. First, the Nikon model has a tripod collar which makes switching from landscape to portrait format quick and simple. It won't throw the tripod off balance, and the support close to the centre of balance of the camera puts less force on the tripod bush. Secondly, the 200mm focal length allows for a very comfortable working distance between myself and the subject. I am always ill at ease when I am compelled to position my lens close to the subject, as with short-focus lenses. Thirdly, it is pure joy to be able to compose the background, since the long focus reduces the angle of view to a very narrow section behind the subject.

Let me clarify this point about the differences in the rendering of the background, as it is an important one. First of all, the way the subject itself appears in a picture taken with any of the three macro lens categories we have been discussing is much the same, except that a short focal length gives a steeper perspective. The depth of field, too, is the same for a given f-number, and the magnification of the subject is the same. But the angle of view is very different, becoming less as the focal length increases. The less area have to contend with in the background, the easier it is for me to blend whatever is there in terms of colour and out-of-focus forms into my composition, with just small adjustments in the camera position. I have obtained a great deal of satisfaction from taking close-ups with this lens.

Telephoto lenses

Optical designers seem to run into trouble with zooms that cover focal lengths greater than 200mm. This may be because telephoto lenses are designed to be physically shorter than their effective focal length, so that the rear nodal point (from which the focal length is measured) is well in front of the lens instead of being inside it, as it is in a lens of traditional design. Be that as it may, my experience with tele-zoom lenses covering moderate to extreme focal lengths is that at their shorter focal

lengths they are capable of excellent results, whereas in the middle range they are only reasonably good, and at their maximum focal lengths the results are barely adequate. They are thus bad news for nature photographers, who generally use the longer ranges the most.

The recent introduction of low-dispersion (LD) glasses has made it possible to improve the design of telephoto zoom lenses greatly. The best telephotos, both fixed focus and zoom, are those which incorporate LD glasses in their construction. The manufacturer usually indicates the use of such glass by annotations such as 'L', 'LD', 'ED' or 'Apo'.

It is always difficult to say which lenses someone might need, and what maximum apertures and focal length ranges would be most appropriate, as personal preferences, types of subject matter and techniques differ greatly from one photographer to another. For myself, I would never use a telephoto zoom when working in Europe or America. I would rather use two lenses, an 80–200mm f/4 zoom lens and a 300mm f/4 fixed focal length lens. But for my work in Africa I would dearly love to be able to have a 100–300mm f/4 AF zoom of Canon or Nikon quality!

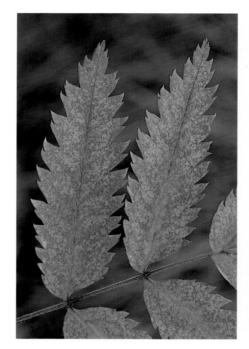

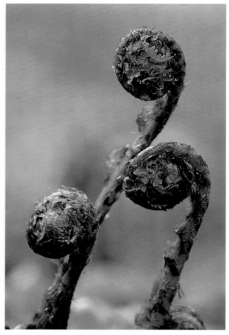

Top left: Rowanberry leaves (X3), Bayerischer Wald Nature Park. 200mm f/4 macro lens, Fujichrome Velvia pneumatic release.

Top right: Lady fern, Bayerischer Wald National Park. 200mm f/4 macro lens, Agfachrome 50 pneumatic release.

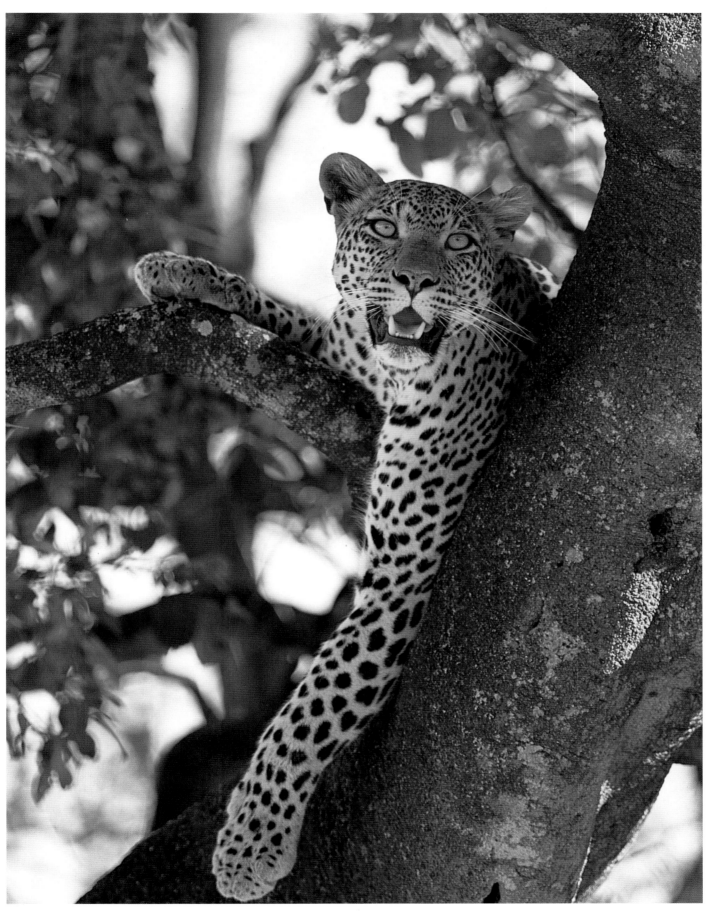

Female leopard, Masai Mara, Kenya.
Nikon F4, 600mm f/4, Fujichrome 50.

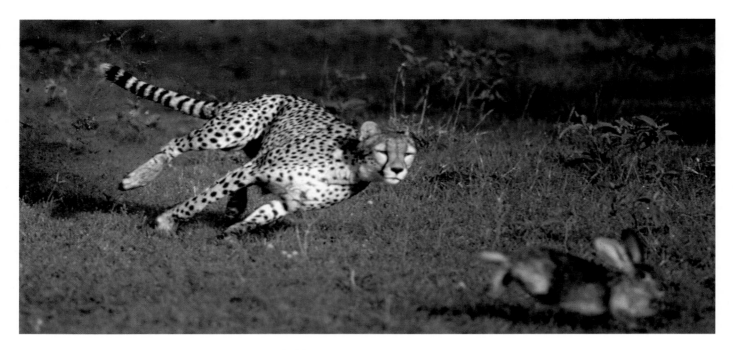

400 mm f/2.8 and f/5.6 telephoto lenses

If you want to buy only one of the long-focus lenses, then in my view the optimum for nature photography is the 400 mm. It often turns out to be the ideal lens, and just by moving a few steps forward in your camera position it will do duty for a 500 mm lens; or, by taking a few steps back, for a 300 mm lens. The 400 mm focal lengths are effectively the longest ones that can still be hand held. They don't require the heavy tripods and ball heads that the longer 500 and 600 mm lenses need, and are less susceptible to camera shake. Thus with these more compactly built lenses you can shoot with exposure times that would give you unsharp images with longer focal lengths.

400 mm lenses tend to be optically better than the longer focal lengths, too, and this is confirmed by test reports. The 400 mm f/2.8 is particularly desirable for action shots. For our purposes, however, these lenses are too heavy and too large. For uncomplicated photography the 400 mm f/5.6 lenses with LD glass are ideal, and if you want to buy only one telephoto lens I recommend the 400 mm f/3.5 or f/4. Tamron makes a very good one. They are half the weight of a 400 mm f/2.8, and you lose only half a stop of speed. With a X1.4 converter you have a very good 560 mm f/4.5 or f/5.6 telephoto lens.

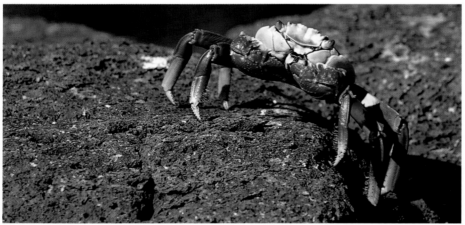

300 mm f/2.8 and 300 mm f/4 telephoto lenses

The favourite telephoto lens of my colleagues in the USA is the 300 mm f/2.8. If you look closely, though, they almost always have a X1.4 teleconverter added. You may conclude that even when shooting tame animals a 300 mm won't do for animal photography. The focal lengths that are most useful are the long telephotos of focal length 400, 500 and 600 mm. If I do work in the 300 mm range, I rarely use the 300 mm f/2.8, but reach for a Nikon 300 mm f/4 AF instead. The quality of this 300 mm f/4 lens with LD glass matches the 300 mm f/2.8, but it is only one-third of the price and half the weight.

My main argument for the slower, smaller and lighter versions is that they are faster to use. By the time I have a 3 kg

Top: Cheetah chasing hare, Masai Mara, Kenya. 300 mm f/4 AF lens in AF mode, Kodachrome 64, car window support.

Bottom: Rock crab, Galapagos Islands, Ecuador. 300 mm f/4 lens, Kodachrome 25.

300 mm lens in position I could already have taken five photographs with the lighter lens. Besides, I don't want to have to carry a 3 kg lens as well as a 3 kg 500 mm lens. Of course, with the 300 mm f/2.8, with the addition of a X1.4 teleconverter I can also have a 420 mm f/4, and a 600 mm f/8 with a X2 converter. but with the f/4 lens and the teleconverters I have the same range of focal lengths at only one stop less. Unfortunately, with the X2 converter the smaller lens will not operate the autofocus.

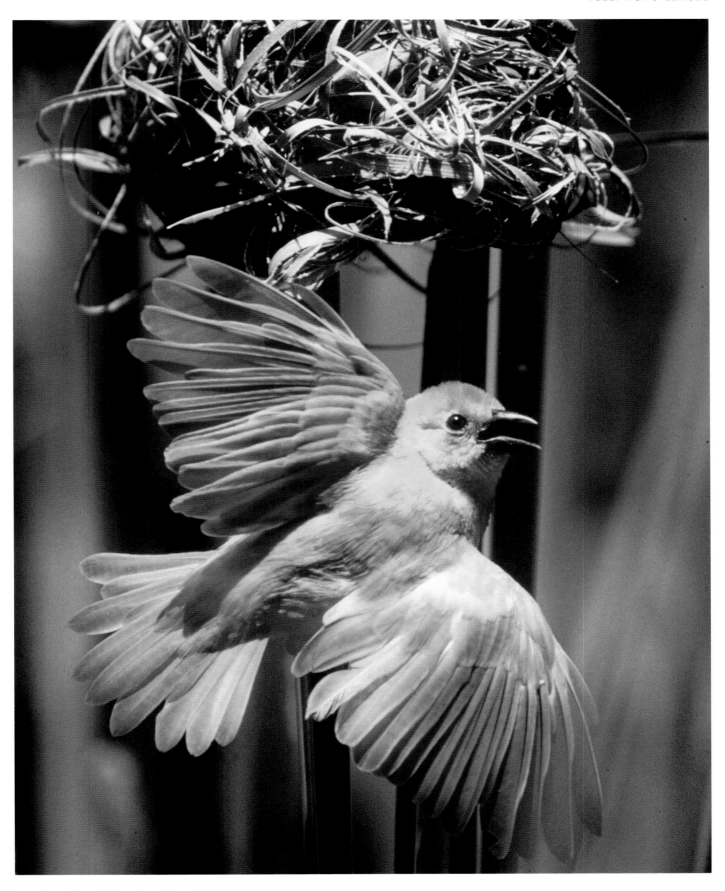

Golden Palm Weaver, Mombasa, Kenya.
Nikon F4, 400mm f/3.5 lens, Fujichrome 100.

500 mm f/4 and 500 mm f/4.5 telephoto lenses

The 600 mm lenses were never very popular in Europe as they are so heavy. This doesn't seem to matter in the USA, where there are a good many 600 mm f/4 lenses in use. At least, there were, until the 500 mm f/4 Nikkor came on the market a few years ago. Suddenly I saw my colleagues in Yellowstone or the Everglades toting 500 mm lenses, and it was at this point that the 600 mm lenses seemed to vanish within a season.

It really makes a difference whether a lens weighs 3 kg or 6 kg when it has to be carried around in the field. If there is any optimum compromise in the long focal length range for wildlife photographers, then it is, no doubt, the 500 mm f/4 or f/4.5. This lens is still easily packed with the other photo gear, is manageable in terms of weight and can be used on a medium-sized tripod with a 1 kg ball head. The apertures of f/4 or f/4.5 are quite accommodating and the 500 mm focal length is sufficient for most situations. Should one need a greater focal length, then a X1.4 AF converter with the 500 mm f/4 will give you a 700 mm f/5.6 autofocus lens of good quality.

600 mm f/4 and 600 mm f/5.6 telephoto lenses

The dream lens for wildlife photographers would be a 600 mm f/4 AF lens weighing no more than 3 kg. There have been rumours for years that such a lens with thin, lightweight elements is just round the corner. Most photographers feel that a 6 kg lens is just too much if they are to continue to enjoy nature photography. These are lenses for sports photographers who drive to a stadium and work with all mod cons – including an assistant to help carry the gear. Lenses of this sort are an imposition for people who have to carry everything themselves. I remember one morning by the Anna Lake in Hanover, waiting to photograph the great crested grebe, and a photographer appeared bearing one of these lenses in great big case. The car park was five minutes away, and by the time he had fetched his heavy tripod and the rest of his gear it was half an hour later. That is the penalty for working with such monsters: they kill any spontaneity. The best alternative available at present is a 3 kg 600 mm f/5.6 MF lens.

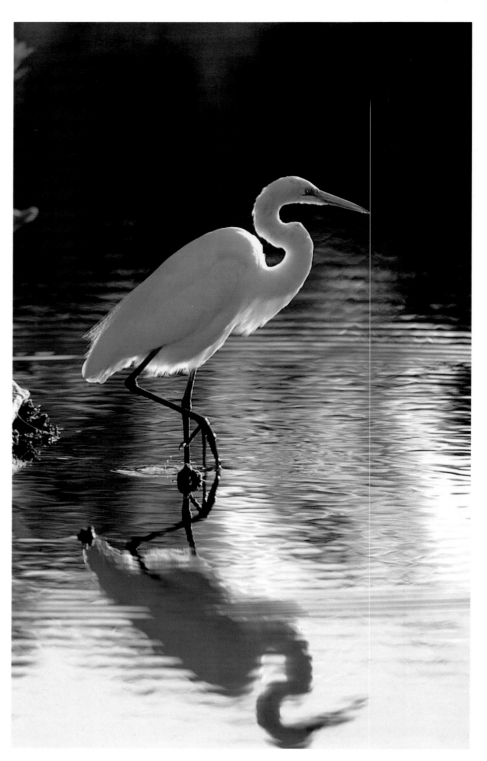

Backlit silver heron, Sanibel Island, Florida. 500 mm f/4 lens, Kodachrome 64.

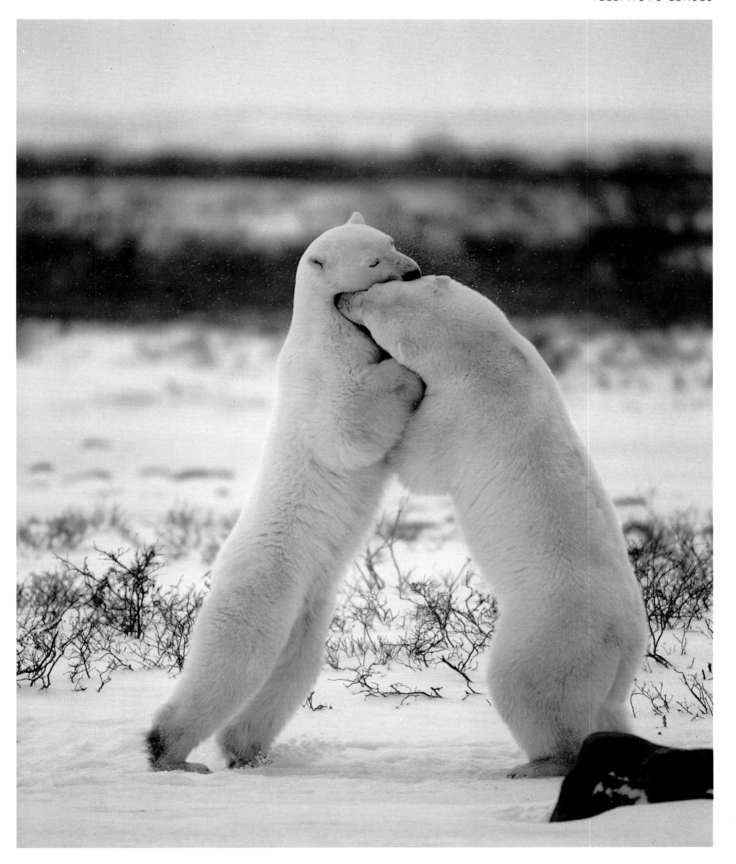

*Playful polar bears in Hudson Bay, Canada.
500 mm f/4 lens, Kodachrome 64, car
window support.*

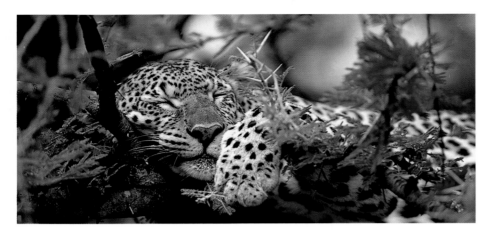

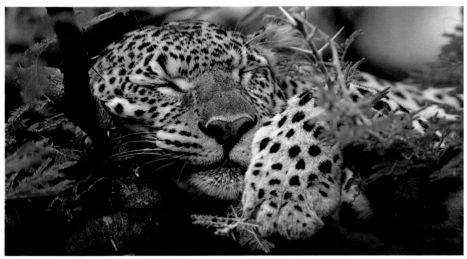

Female leopard asleep in an acacia tree, Masai Mara, Kenya. 600mm f/4 lens, top photo without and bottom photo with X1.4 teleconverter added to tighten the composition on the essential subject matter. Fujichrome Sensia 100, car window support.

Teleconverters

A good deal has already been said about teleconverters. They are devices which, though having no focusing power, extend the effective focal length of a lens when they are fitted between the lens and the camera body. A high-quality, expensive teleconverter is a strongly recommended purchase for a wildlife photographer using long-focus lenses. It extends the focal length of the basic lens by 40 or 100 per cent, sacrificing one or two stops respectively in speed. In theory the optical quality is bound to suffer; in practice the system is corrected in such a way that the residual aberrations are well out in the field and thus do not affect the image area.

The rule of thumb is that the better the quality of both the prime lens and the teleconverter, the less the loss in image quality. Good teleconverters magnify the defects of poor lenses: they cannot correct them. It is, though, extraordinary the way one can turn a 500 mm f/4 AF lens into a 700 mm f/5.6 AF or even a 1000 mm f/8

(MF only) by simply inserting a relatively lightweight converter between the camera body and the lens.

The ability to increase focal length means that pictures can be better composed through tighter framing. An old rule says 'If you can't make it good make it big'. Quite often pictures only really work when a converter is used, because of the tightening of the framing. It is also worth remembering that a teleconverter used in close-up photography will magnify the image by 40 or 100 per cent without your having to change the camera position, for this your prime lens should be your macro lens.

With a X2 teleconverter you are taking a bit more of a risk, optically. But to be able to double the focal length of your lens seems almost too good to be true. The trade-offs are greater, of course. Any flaws in the prime lens will be emphasised more than with the X1.4 converter, and you will lose two stops rather than one. You are also likely to lose any AF function, or at least inhibit it.

Thus, although a X1.4 teleconverter can be a real asset, a X2 converter should be reserved for occasions when the effect of an extreme telephoto is really needed. Animals passing in front of the sun's enormous disc can be very effective, especially as the lighting is so extreme as to mask any inferior lens performance.

To summarise: you have to make the decisions on your lenses, from extremely wide-angle lenses to extremely long-focus,within the frame of the task you will be expecting them to carry out. Choose them carefully: they will be your companions for a long time.

Cheetah yawning, Masai Mara, Kenya. Nikon F4, 400mm f/3.5 lens, Fujichrome 50.

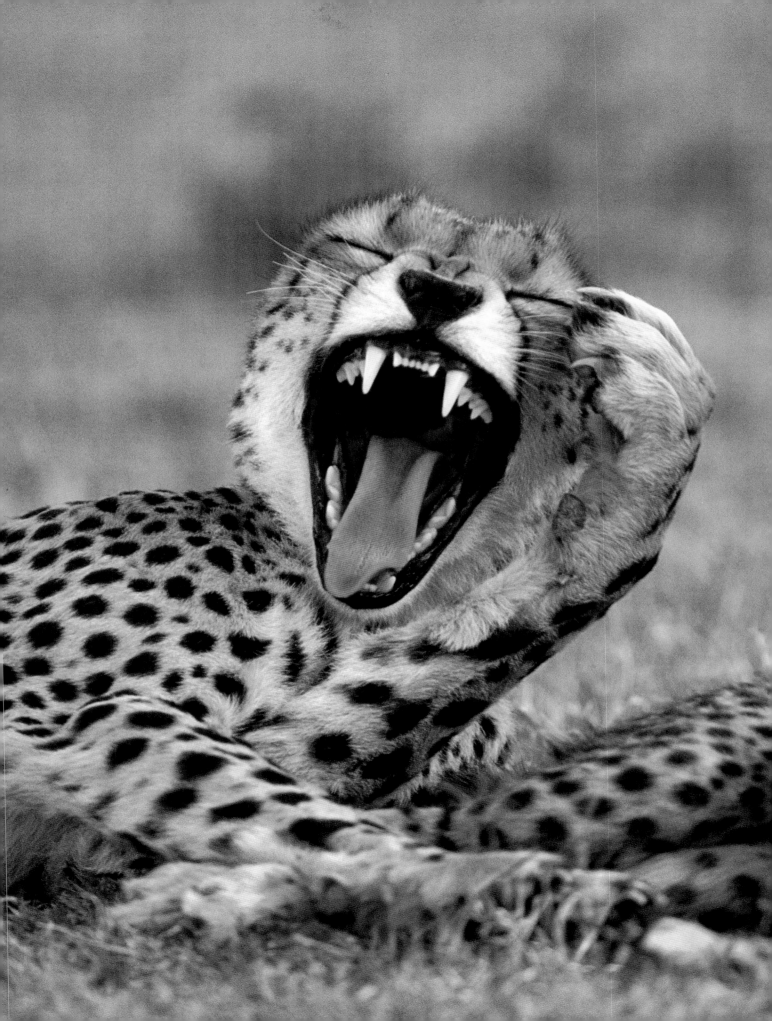

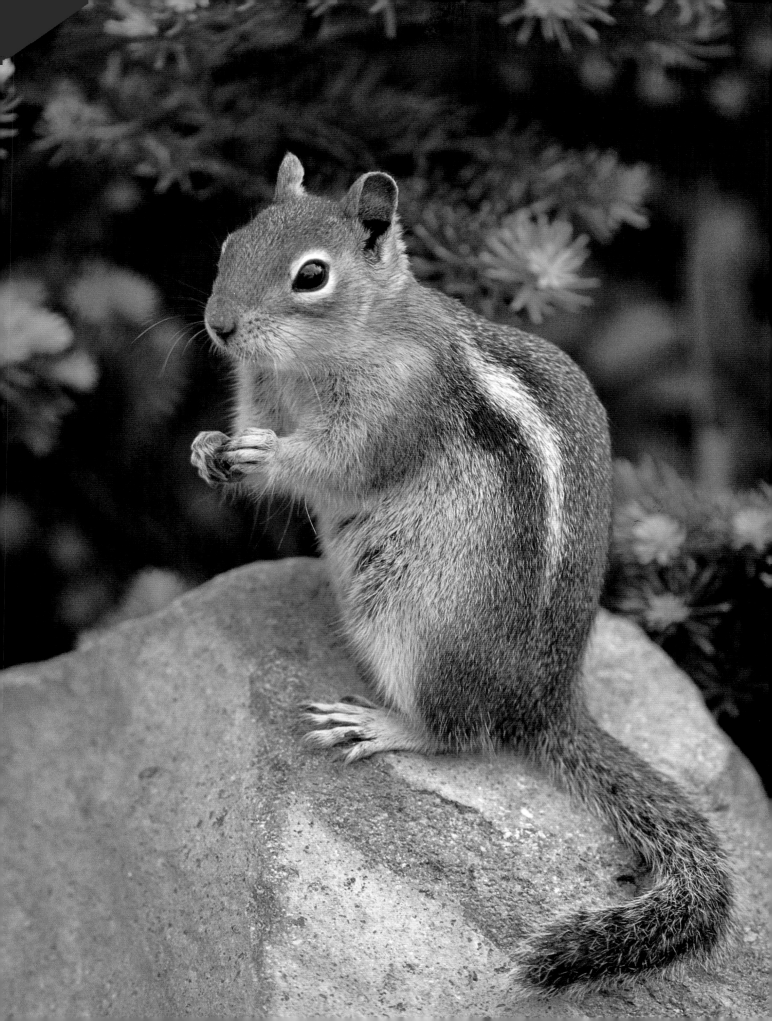

ACCESSORIES

Without a tripod you take snapshots; with a tripod you take photographs.

Anon

Tripods

The most important accessory for the nature photographer is the tripod. Before I discovered the world of close-up photography my favourite tripods were the Gitzo series. These tripods are sturdy, solid, not too heavy, and reliable – a pure joy to work with until it comes to making close-ups. This kind of work demands frequent adjustments to the leg lengths, and I almost wore out the palms of my hands with the repeated loosening and tightening of the twist locks.

Rather than give up close-up photography altogether, I began a search for a more appropriate support. My search eventually led me to what is now known as the Manfrotto MA 055 CB Triminor (Bogen 3221 Black in the USA). It is suitable for lenses weighing up to 3 kg. I modified it by removing the centre column and having the tripod head mounting plate fixed directly to the tripod. (I believe that centre columns turn what should be a sturdy tripod into a kind of hybrid monopod mounted on a tripod.)

For general wildlife photography I still use my Gitzo tripod, as for this work one doesn't need to be constantly changing the height of the camera. The heavier Gitzo tripods have wing nuts instead of twist locks on the upper leg extensions; this makes them much more user-friendly.

When you use a camera on a tripod rather then hand held, yon get more time to contemplate the scene, to consider

Golden-mantled ground squirrel, Olympic National Park, USA.

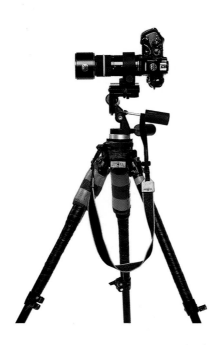

My most important tripod is the Manfrotto 055 B with the Manfrotto three-way tilt head 141 RC, with the column modified as described in the text. The leg joints were milled so that it could be placed flat on the ground, and a small threaded plate was fastened underneath the tripod head to allow the attachment of an umbrella (adjustments made by the Burzynski Co).

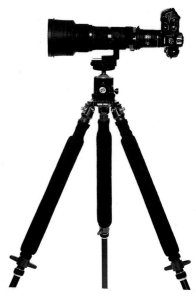

The tripod I use for wildlife photography with lenses weighing 2–4 kg is the Gitzo No. 340 Performance which comes without centre column, weighs 2.8 kg and can support up to 10 kg. It has a maximum working height (with a ball head) of 1.70 m. Folded up it measures 71 cm, and can fit into any suitcase.

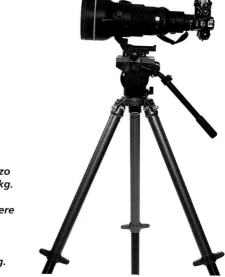

Outdoor photography is a lot of fun with the first two tripods, the Manfrotto 055 B for close-ups and landscapes, and the Gitzo 340 for wildlife shots with lenses up to 4 kg. For a 6 kg telephoto lens both tripod and head have to be very sturdy. My choice here is the Gitzo Performance 500 which can support a load of up to 15 kg, with a Manfrotto 116 Mk3 three-way tilt head. The tripod and head together weigh 15 kg.

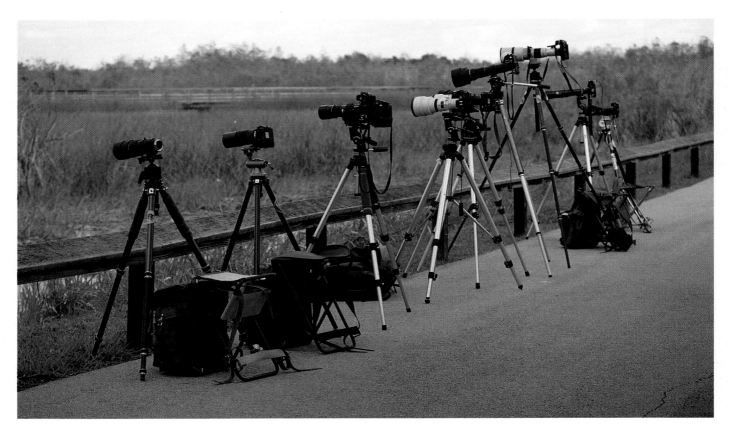

refinements in perspective and composition such as the position of the horizon line, the location of the most important areas in the scene, the niceties of focus and depth of field, whether anything in the foreground or background spoils the composition, and so forth. This awareness makes a real contribution to the success of your composition.

Tripod heads

A tripod head gives you fine control over the framing and balance of the elements within the scene. It simplifies camera positioning, and in general adds so much to the enjoyment of photography that some form of tripod head must be considered essential.

A three-way tilt head, as its name suggests, employs three levers, controlling respectively horizontal, vertical and axial rotations of the camera axis . By easing off the levers one at a time you can make fine adjustments until you are completely satisfied with the composition. I particularly appreciate this facility when I am composing a close-up picture with my 200 mm f/4 macro lens .

Ball heads are operated by a single control which allows movement in all directions. They are unbeatable for speed

in positioning the camera. All you have to do is to slacken off the single control knob a little, and you can adjust the camera axis in any direction. In my work I exploit the advantages of both types of head, using a three-way head for close-ups and landscapes and a ball head for wildlife photography, where speed can be a decisive factor. The illustration shows both the Manfrotto fitted with a three-way tilt head and the Gitzo fitted with a ball head. The 600 mm f/4 is mounted on a sturdy cinematic tilt head, as smaller ball heads

Above: A row of tripods set up ready for photography. There are many different types of tripod, it is important to choose one that is both sturdy and quick to adjust.

Below: Ball tripod heads allow movement in all directions, they are unbeatable for speed in positioning the camera.

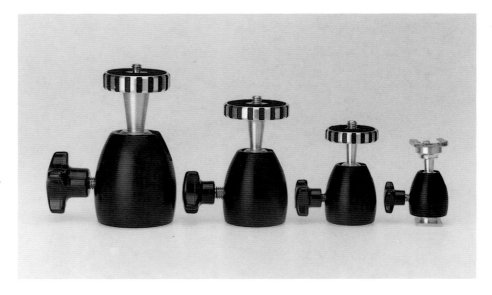

are not suitable for lenses weighing 6 kg or more. I use a 1.6 kg Lumpp ball head for this lens.

For close-up photography, however, I don't recommend a cinematic head because of its long guide lever: I prefer a three-way tilt head with a quick-release plate . There are several good ball heads available, for example the Linhof III. After a little field testing I opted for a Studioball. It has few if any drawbacks, is of robust construction, and can manage lenses of 3–4 kg well. Unfortunately, even my favourite Studioball didn't have a safety stop for the mounting screw. Some cameras can't be tightened down far enough because the tightening screw is too long and the adjustment controls are on the wrong side.

If you examine the illustration of the four ball heads you will notice that only the Studioball has provision for tilting right down to the vertical. Also, the surface of the adjusting knob is very hard; in this respect the Linhof is much better. Another annoyance is the small wing nut on the bottom right, which should be a good-sized knob. Most cameras have their shutter release and exposure controls on the right, so you have to operate them with your right hand. So why not put the ball head adjustment and lower pan knob together on the left? You would think it would be an obvious design feature, yet most manufacturers don't seem to have thought about this, as you can see from the illustrations.

Taking all these points into consideration, the ball heads I would recommend (in descending order) are the Studioball, the Linhof III, the Foba and the Lumpp (if weight is no problem). A recent arrival on the market is a ball head by Burzynski, which appears to be excellent for lenses of 3–4 kg.

Quick-release systems

A quick-release device operates between the tripod head and the camera or lens tripod collar, to avoid the inconvenience of having to mount the camera on the tripod head by turning it round and round. You just loosen a conveniently-placed knob and slide the camera off the head. There are two parts to these devices, a base attached to the tripod head and a plate fitted to the camera tripod bush. These lock together by means of a quick-release lever. The systems

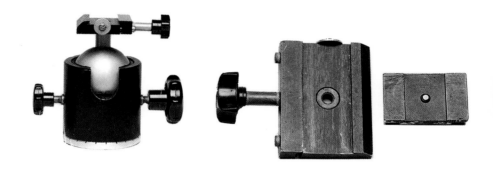

Quick-release plate on top of the ball head with an added safety stop, a screw and a washer installed at the end of the plate. You will need to get the necessary thread tapped for you. The quick-release system can also be used as a crude focusing stage.

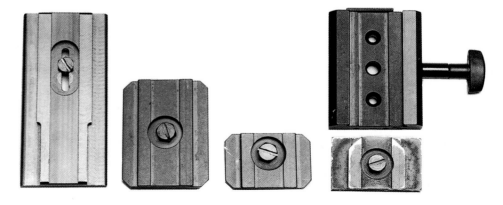

You can also attach different size plates permanently to camera bodies and lenses. On the left is a custom-made plate with a slit which allows for movement of the camera lens unit should the centre of gravity change.

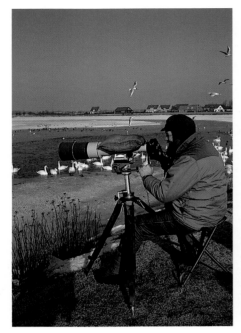

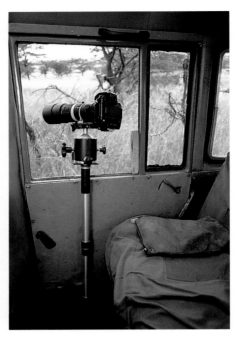

Far left: Here Uwe Waltz is using a sandbag to steady the camera during the exposure. Use a sandbag or beanbag as a tripod substitute only as a last resort; results will be better with a car window support.

Left: Typical working set-up from a car: the Novoflex Window Clamp is fastened to the window, with a Lumpp Ball Head attached for my heavy lenses. The weight of the camera and lens is on the monopod, and the window clamp ensures the whole assembly does not topple over.

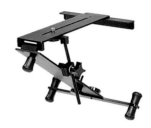

This Rue Window Support has the advantage that you can slide the camera back into the car if it rains. It cannot be attached tightly to the window, however, which makes it a bit shaky.

The Novoflex Window Clamp has tightening screws and comes with a thread to which a monopod can be attached. Unfortunately, it is no longer made. However, an improved version is available from the Burzynski Company.

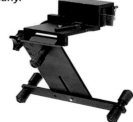

Mike Kirk created this window support by combining the front portions of the Rue and Novoflex Window Clamps. It can be screwed to the window and has a small added support. For heavier lenses you need a thread added to support the entire unit on the door handle or the car floor via a monopod.

manufactured by Manfrotto or Linhof are very popular. However, they provide you with only one size plate. This is fine if you're using a lightweight camera and lens, but when you are working with a 6 kg lens you need a longer plate for a better hold. The system available from Foba, Arca-Swiss and others, is more suitable, as plates of different lengths are provided.

This type of system has two advantages. First, the slot in the holder provides longitudinal adjustment of the camera position to allow for better balance. Secondly, these longer base units can also serve as a coarse focusing stage in close-up photography. This means that you can do your rough setting up without having to move the tripod, saving a great deal of time.

Vehicle window supports

In Germany it is possible to photograph a lot of wildlife such as deer, rabbits and pheasants directly from a car, which thus serves as a kind of mobile hide. In the USA conditions are even better, and in Africa practically all photography is carried out from a vehicle. The simplest and most frequently-used accessory for this is a little bag filled with beans, rice or polystyrene granules, which is placed on the edge of the window and used as a soft, firm cushion for the lens. A beanbag also allows you to set up a camera position on the roof of the vehicle quickly. a slightly different kind of bag is a sandbag placed on top of

the camera to steady it. A cotton glove filled with coarse sand and tied at the wrist is perfect for the purpose, though it may look a little creepy. Never use the camera hand held if you can avoid it: use a window support.

A window support is designed to fit against the door and window. It will not only keep the camera steady, but will also allow you to examine the image in the viewfinder and make decisions about what to photograph. It also permits longer exposure times and smaller apertures. A window support works best if you can also brace it against the door, so that it is really stable if you are using heavy lenses. Some makes have built-in supports which are sufficient for 300 mm f/4 lenses. For heavier lenses you need to be a little more creative. For example, you can adapt a Novoflex gunstock support by screwing it into the window support and letting it rest against the door handle. The sturdiest set-up is with a monopod screwed into an old Novoflex car window clamp (if you can find one), or attaching the monopod to the one made by Burzynski.

Remote shutter releases

If you make a rule of always using a remote shutter release for landscapes and close-ups you're never likely to suffer from camera movement as you operate the shutter release. (If you find on a field trip that you've left your remote release behind, use the self-timer.) The type of remote release you use depends on your preference and the capabilities of your camera. Most camera bodies have a tapered screw socket for a cable release, plunger operated, or a pneumatic (bulb) release. A few cameras need a dedicated electronic cable release connected to a socket on the camera body, tripping the shutter by closing an electrical circuit. My personal preference is for the pneumatic type, partly for reasons of nostalgia, partly for reliability, but more because the electronic cable release on my Nikon F-4 is on the front of the camera body, whereas the mechanical cable release is on the back, and is thus more accessible when the camera is on a tripod.

Another good reason for using a remote control is that if you are waiting patiently for some unpredictable event (such as a goshawk returning to her chicks) it is much less tiring to hold a remote release than to sit for an unspecified time with Your finger hovering over the shutter release button.

Close-up accessories

In close-up work in the field you need to be able to set up and use equipment that will record the subject large enough to show details normal distance photography doesn't reveal. Photomacrography, strictly speaking, means the making of a photographic image that is lifesize or larger, i.e. a scale (or magnification) that is 1:1 or more. There are several ways of obtaining large image magnifications. The most usual is to use a large lens extension, either by fitting extension tubes between the lens and the camera body, or by fitting extension bellows. The greater the extension the closer the lens will focus and the larger the magnification ratio will be. Another way is to add a supplementary lens to the front of the prime lens. The shorter the focal length of the supplementary, the greater will be the magnification ratio. The ultimate in 'supplementaries' is an actual camera lens

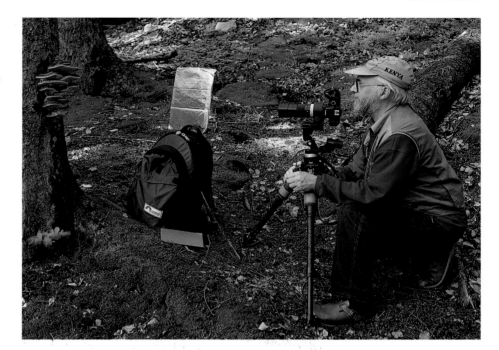

Above: My standard gear for close-ups includes the 200 mm macro lens with tripod collar on top of the three-way tilt head on a Manfrotto tripod. Next to the backpack is the grey card to compare the reflectance of the subject with a standard middle grey. Above the pack is some gold foil to lighten the shadows of the mushroom and to counteract the cool blue colouring of the shadow areas. In my hand is the pneumatic release which allows me to wait, relaxed, for the right moment to release the shutter. The camera has its viewfinder blind closed to prevent stray light from entering the viewfinder from the rear.
Photo: Gisela Pölking.

added to the prime lens. We have already noted the use of a teleconverter to increase the focal length of the prime lens.

I don't as a rule use a bellows extension myself, as they take up a lot of space when I go out on foot; and at other times I have little call for one. They are much less useful than in the days before we had the present range of high-quality macro lenses. Personally, I prefer to work with dedicated extension tubes, with which I can focus at full aperture for a bright image. Bellows units vary greatly in their features, some being very sophisticated. However, many require stop-down metering, and all are slower to set up than a macro with or without an extension tube. They come into their own for really big magnifications (2:1 to 10:1). If you do go for a bellows extension, make sure you buy one that has a rail that allows you to move the whole camera along its axis; this greatly facilitates focusing and choice of scale. It should also allow the camera back to move independently, for fine focusing.

I always carry a 27.5 mm extension tube in my camera bag. I have found this a useful accessory for close-ups and for

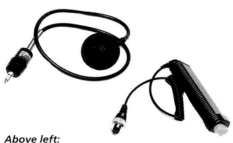

Above left:
HAMA Pneumatic Release 'Pneu' No. 5360.

Above right:
HAMA Cable Release 'MD' No. 394.02.

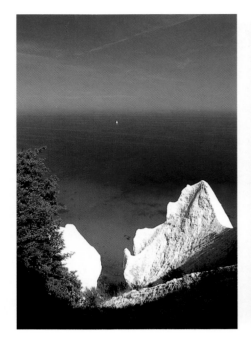
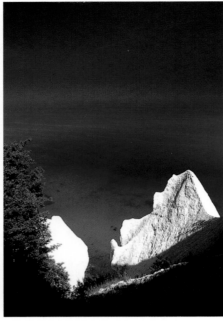

The chalk cliffs on the Isle of Rugen taken (left) with a polarising filter and (right) with a polarising filter plus a neutral grey X4 graduated filter to darken the upper sky. 24 mm f/2.8 lens, Fujichrome Sensia 100.

portrait shots with my longer telephoto lenses, the 500 or 600 mm, where I have to stay at a distance from my subject. An example is the picture of the kingfisher (p. 58). This shot would have been impossible without both a teleconverter to obtain the necessary focal length and an extension tube to obtain close enough focus.

Supplementary lenses are unjustly ignored by many photographers. They are usually available in powers of 1, 2 and 3 dioptres (i.e. focal lengths of 1 m, $\frac{1}{2}$ m and $\frac{1}{3}$ m respectively). Don't buy cheap ones: they are single glasses and are not corrected for chromatic aberration, and can give coloured fringes near the edges of the frame. Go for well-corrected supplementaries from the camera manufacturers.

Supplementary lenses have a much greater effect on long-focus lenses than on standard lenses. The Nikon T5 close-up lens, for example, allows me to focus with an 80–200 mm f/4 zoom lens on an area of 45 X 70 mm, small enough for a flowerbud or a small beetle. When I don't want to take both the 80–200 mm f/4 zoom and the 200 mm f/4 macro with me as well, I simply take the zoom and the T5 supplementary lens as a substitute 200 mm 'macro'.

An important point in favour of supplementaries is that they don't increase the effective f-number as do extension tubes; but because they are simple

achromats they are not fully corrected, and give their best performance when stopped down.

When I need to move in even closer than these two methods allow, I mount two lenses face to face, using a special connecting ring. These 'reversing rings' fit the filter threads of the lenses and couple them together. With both lenses set to infinity you get a 1:1 image scale, and by using the focusing rings of one or both lenses you can obtain large magnifications, still with good optical quality. Of course, the outer lens will not stop down, but this is unimportant, as the size of the entrance pupil is controlled by the iris diaphragm of the prime lens. With this system you can take macro shots up to about 10:1 magnification without any loss of optical quality.

Polarising and other filters

The popular belief about polarising filters is that they serve only to darken a blue sky and thus render clouds whiter. While they certainly do this, in nature photography polarising filters have other applications. Colours appear ,stronger, because the filter removes specular (surface) reflections which degrade colours. Also, a polarising filter will reduce the blue cast in landscape pictures. At the same time it will cut down or even eliminate reflections from any shiny nonmetallic surface such as water or plate glass. The filter will need rotating in its mount until the best effect is achieved.

At rear: 52 mm extension tube complete with tripod collar. In front, left: my much used 27.5 mm single extension tube. Front, centre: smaller tube used with 20 mm and 24 mm wide-angle lenses. Right: 52/52 mm ring for coupling two lenses which allows you to photograph at several times life size without the necessity for a long bellows extension.

Above: Polarising filter for telephoto lenses.

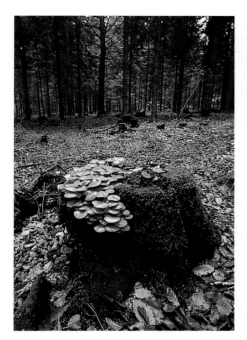 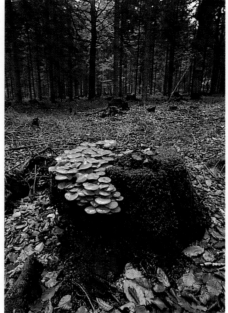 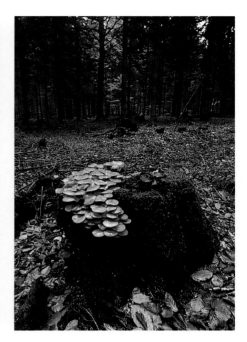

Honey fungus in the Bayerischer Wald National Park. Left: Shot without filter: centre: polarising filter set halfway; right: polarising filter set to full effect. Notice how, in addition to the effects on reflections, the colour of the leaves, fungus and moss change in both hue and saturation. 20mm f/2.8 lens, Kodachrome 64.

When shooting close-ups in the shade or in the evening the blue component of daylight is high, and slide film will show a bluish cast or at best a cold tone. You can avoid this by using a pale amber or 'warming' filter. The best are Kodak's 81A or the stronger 81B. You can buy these as gels to hold in front of the lens, or as optically flat glass in a mounting ring for the front of the lens. If the cast is very slight you can simply use Kodachrome 200 slide film, which has an inherently warm tone.

Another useful filter for nature photography is a graduated neutral-density filter, which is a must where there is a high brightness difference between two major areas in the scene, such as between foreground and background, or land and sky. I found such a filter essential when I was photographing in Iceland, with dark tundra in the foreground and snow-covered mountains in the background. Quite often there will be a contrast of over 200:1 between the two areas, and no slide film has that kind of latitude. A neutral grey graduated filter (available in different

density grades of 1, 2, 3 and 4 stops difference) will even out the differences in brightness between foreground and background. You can also use one to tone down other bright areas, as I have done with the chalk cliffs on the island of Rügen.

Choice of films

If you are making a choice between different colour negative films, then the brand is not very important. almost all of them will give good results. The effect of different film speeds on quality is also less than with colour slide films. It is only in big enlargements that the increased graininess of high-speed colour negative film becomes apparent. But the best colour negative film is useless if the processing lab uses poor quality print material, or doesn't properly match the colour balance of the printing light source to that of the negative.

With slide film (reversal film), things are a little more complicated. The slide (or transparency) itself is the end product. What is in the film gate at the moment of exposure is what you will finally get. There is no second stage to give room for correction of errors in density, contrast or colour balance.

Many years ago choice was strictly limited. There was Kodachrome 25 for close-ups and Kodachrome 64 for wildlife. The choice has expanded dramatically, especially over the past ten years. Although

many photographers still swear by Kodachrome, most professional photographers use mainly Kodak Ektachrome (which arguably gives the most accurate colour rendering) or Fujichrome Velvia (which gives high colour saturation and more vivid pictorial effects). If you examine any coffee-table book of photographs you will probably find that nine out of ten of the pictures were shot on one of these films. Fujichrome Sensia is a film giving softer and more neutral colour rendering, and is also popular among nature photographers. Fujichrome Provia is the same emulsion, but is more expensive as the colour balance is rigidly controlled from batch to batch.

There are many other excellent slide films on the market, too many to discuss in detail. One important point concerns the difference between 'amateur' and 'professional' films. There is no difference in quality, but professional film is designed to give its best results when kept in cold storage and processed immediately after exposure, while amateur film does so when kept under normal storage conditions for up to six months and not processed until several days or weeks after exposure. Which type you should use depends on the conditions under which you will be carrying out your project.

The quality of the results from ISO 25, 50 and 100 speed films available today varies from good to excellent, while that of ISO 200 and 400 films varies from good to

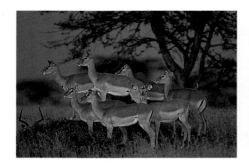
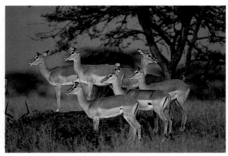
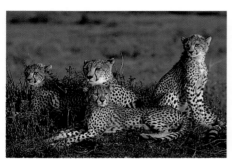
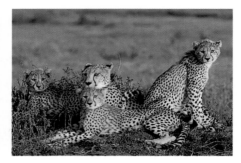

(top row): Impalas before sunrise, Masai Mara, Kenya. Just before sunrise when the sky was glowing red. Left: Kodachrome 200 film turned out decidedly red; right: Sensia 400 film gave a very neutral rendering. 400 mm f/4 lens, car window support.

(bottom row): A female leopard and her three cubs. Masai Mara, Kenya. Left: Kodachrome 25 (used here) and 64 don't give very high colour saturation, and may appear dull when mixed in with slides made on modern daylight-balanced films. Right: Velvia exaggerates colour saturation but gives a more lively result. 400 mm f/3.5 lens, car window support.

mediocre. Still faster films should be used only as a last resort when lighting conditions are poor. Always choose the slowest film you can get away with if you want the best quality transparencies. Mind you, if you want to capture the flight of a colony of bats leaving their roost at dusk you'll need the fastest film you can lay your hands on, and may even need to have it push-processed. Under such circumstances you may give thanks to the chemistry wizards who have managed to produce ISO 1600 emulsions!

Films are improving all the time. In an early draft of this book I wrote that the new (1995) films were 'a dream come true'. Now, only two years later, the advent of the APS camera with its smaller format has resulted in a further revolution in emulsion technology. One now hesitates to say that photographic films have come anywhere near to their ultimate quality.

Hides

I fail to understand why fishermen spend hours sitting by the waterside with rods and lines. Do they really just want to catch fish, or is it largely an excuse to meditate undisturbed? I suppose, to a non-photographer, someone sitting with a camera in a small camouflaged tent near a river, waiting hour after hour for some small water bird to appear, must seem equally pointless. You can get used to such inactivity, however; you can spend hours in a hide just letting the mind wander. Then

suddenly everything happens at once. Are you excited? or are you, perhaps, just a little vexed that this wee birdie interrupted your train of thought?

On a more serious note, you should consider buying or constructing yourself a hide, as it is a very effective way to observe and to capture on film these shy subjects: It is also one of the most satisfying experiences in nature photography, to be effectively invisible, and able to observe and photograph the creatures that appear in front of you. But a word of caution here. Be extremely careful when going near birds' nests. They can't just fly away: duty ties them to the nest. Don't set up a hide until you're absolutely sure that it is not going to disturb your subjects. A good way to do this is to carry the hide a little nearer the nest each day, and enter it only when the birds can't see you. If you're not sure about this, take a companion along and get him or her to leave the hide while you stay. The birds will be deceived into thinking the danger has gone away.

The most comfortable hide for wildlife photography is demonstrated in the illustration by my colleague Jürgen Diedrich. It is by Telse Meyer and Dirk Blumenburg. It can be easily taken on walks, and you don't need a stool. There are two areas protected from the wet ground, where you can stow your film, binoculars, notepad etc. It is sturdily built, and the wooden frame gives it stability, so tie ropes are not needed unless there are

In Africa, I always keep films in a Kodak cooler next to me in the car. I have divided the cooler into four compartments: a large one for ISO 100 films, and small ones for ISO 200, 400 and 1600.

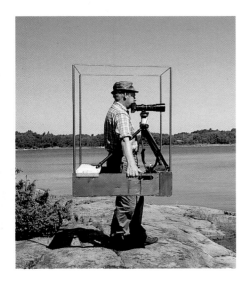

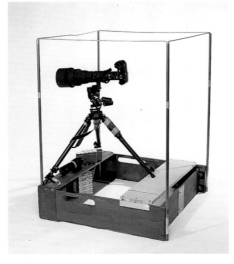

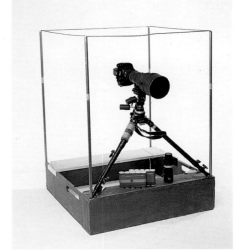

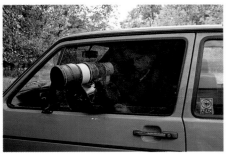

Above and right: This hide is especially useful for following your subjects around, for example between low and high tide. Essential items such as binoculars, notebooks, snacks etc. can be placed on the wooden box, and the whole thing can be carried from the inside. Demonstrated here by the photographer Jurgen Dietrick on the Island of Aland.

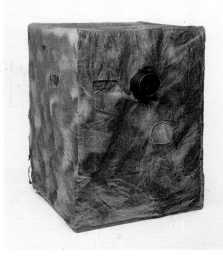

Left: If you use your vehicle as a mobile hide, hang a piece of camouflage netting in the driver's window. Black out the passenger window too, so your head won't appear in silhouette.

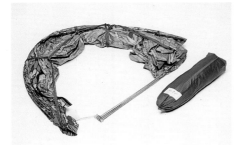

Left middle: The folded-away Rue Tent, weighing 4 kg and occupying a space of 100 x 70 x 10 cm. In front of it, the folded-away Birdland tent, weighing only 1.6 kg and measuring 50 cm x 10 cm diameter, ideal for a suitcase.

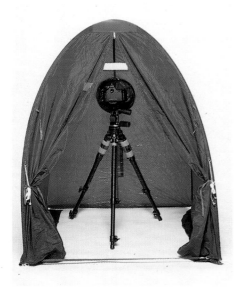

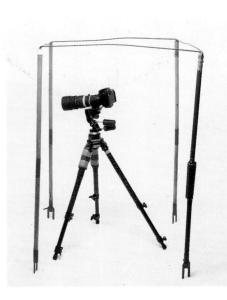

Left: A more modern commercially-available hide. Most of these have flexible tension poles for stability. They are quick to set up, fold up, and are easily carried.

Right: The standard camouflage tent used in the UK for decades by bird photographers.

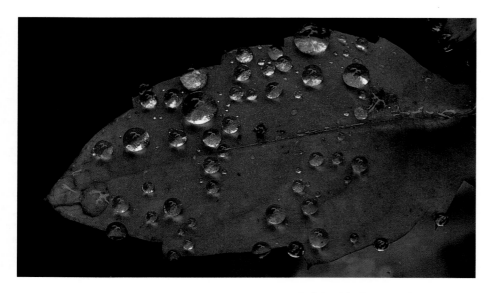

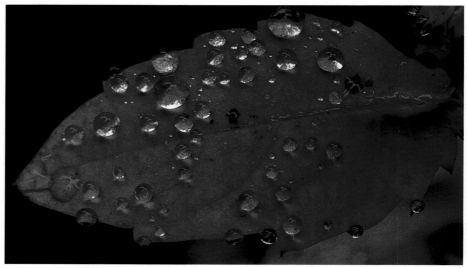

Leaf with raindrops, Falkenstein,
Bayerischer Wald, shot in daylight.
Top picture: Kodachrome 200. The leaf
appears much browner than it really is.
lower picture: Fujichrome 50 has a truer
colour rendering. 105mm f/2.8 macro lens.

strong winds, or the hide needs to be left in place for several days. A plastic sheet can be draped over the top to keep it dry in heavy rain. Altogether, it is a well-designed and well-built hide and is, in my opinion, the best camouflage tent by far. The only drawback is that it is not very suitable for air transport.

Hides are regularly advertised in the magazine of the Royal Society for the Protection of Birds (RSPB). You can also get plans for building your own. The address to contact is RSPB, The Lodge, Sandy, Beds SG19 2DI, UK. If you are interested in building the Meyer/Blumenberg tent (especially suitable for Scandinavia), you can send for the plans to me enclosing a stamped self-addressed envelope, to Fritz Pölking, Münsterstr. 71, D-48268 Greven, Germany.

Storage and transport of equipment

Packing all your equipment and film has to be done with an eye on both safety and protection for the equipment, and the demands of travel, particularly when backpacking or travelling by air. many camera bags can hold large amounts of gear and are fine for carrying equipment short distances. But they can be totally unsuitable when you have to lug them up and down hills all day. In such cases you should consider a camera backpack.

Aluminium cases are sturdy and dustproof. I take one along when I make car trips and want to bring some extra gear, as it can easily be stashed in the boot; but mostly I just use them for storage. If you need an aluminium case, get a green or brown covered one, not the silver type. These seem to carry a large invisible notice:

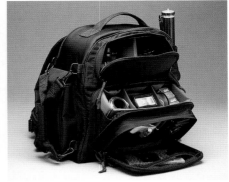

Above: Domke Photo Daypack has a padded adjustable harness and waist belt to carry your equipment comfortably and securely.

Left: My luggage ready for an eighteen-month safari with a family of cheetahs in the Masai Mara, Kenya.

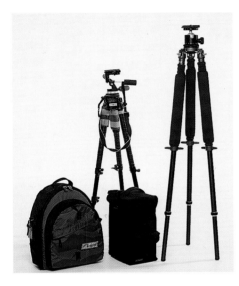

'Steal me, I have valuable stuff inside.' Nowadays I put all my gear into a Lowepro Photo Trekker backpack. Similar camera backpacks are made by a number of European and American manufacturers.

Carrying a large amount of equipment by air can sometimes be difficult. If you are booked on a 747, or if your flight is underbooked, there are usually no problems. But if your aircraft is a smaller one, or is fully booked, you may very well hear the dreaded words 'One piece of hand luggage only.' Hence, on the basis of 'if you can't beat 'em, join 'em', show up with only one piece of hand luggage anyway. Find a bag that complies with the underseat dimensional requirements. You will be surprised how much you can get into it.

That still leaves the problem of transporting film on flights. At all the big international airports the X-ray system will not damage your film, so put the 100 or more rolls of film into your suitcase. On your return, put the exposed cassettes into a transparent plastic bag as hand luggage. Coloured bags imply 'duty free', and there is often a tacit arrangement between airports and airlines not to allow such bags as a second piece of hand luggage. If it is obvious that your bag contains only exposed film you should be allowed through without further examination, and your bag may even be let off the

Above left: For airline travel I confine myself to a backpack and bag as hand luggage. The tripods go into the hold in my suitcase. For car trips I add an aluminium case filled with the odds and ends I only seem to need when I have left them at home.

Above centre: My usual gear for Europe and America.

Above right: A slightly different pack for African trips.

Left: Domke Outpack modular compartmentalised carrying system, everything can be safely opened while the pack is upright, so you don't have to lay it down on rocks or in water or snow.

mandatory X-ray examination.

On the subject of X-rays, it is worth noting that 'Which?' magazine put high-speed colour films through all the Western airports a large number of times and found no evidence of fogging. So don't worry too much if your precious films are zapped several times during your journey.

Final comments

You may be interested in nature photography, but are reluctant to invest a lot of money in equipment to start with. The minimum I would recommend is: one SLR camera with a 28 mm f/2.8 lens for landscapes; a 105 mm f/2.8 for close-ups; and a 400 mm f/5.6 for wildlife photography. In addition you will need a cable release, a polarising filter, a 27.5 mm extension ring, and a Manfrotto or similar

tripod with a Linhof ball head. Put all this into a suitable carrying bag, and you are ready to go.

If, on the other hand, you want to assemble a kit with which you can go around the world and not fear missing any photo opportunity, then I would recommend the following: two SLR camera bodies; for lenses, a 24 mm f/2.8, a 105 mm f/2.8 macro, a 35–70 mm f/3.5 zoom, a 70–210 mm (or 80–200 mm) zoom, a 300 mm f/4 and a 500 mm f/4 telephoto; one tripod and head, and a top-quality camera backpack to transport everything in. And, of course, there are the important extras such as a compact flash, extension tubes, remote shutter release, supplementary lenses, polarising, sky and graduated filters, etc. It is not possible to be more specific, simply because nature photographers do not all have the same

goals. Even if they did, there would always be individual preferences.

Some final remarks about photographic equipment

The Economist recently began an article on the Japanese photo industry with the sentence 'Nowadays, with the introduction of microchip technology into camera systems, even the dumbest Sunday shooters can take photographs like the professionals.' Such ignorant twaddle is exposed if we just change the scenario a little: 'Nowadays, with the introduction of microchip technology into word processing systems, even the dumbest schoolchildren can write novels like D.H.Lawrence.'

The story is told of a nature photographer who was staying at a country house and showed some of his

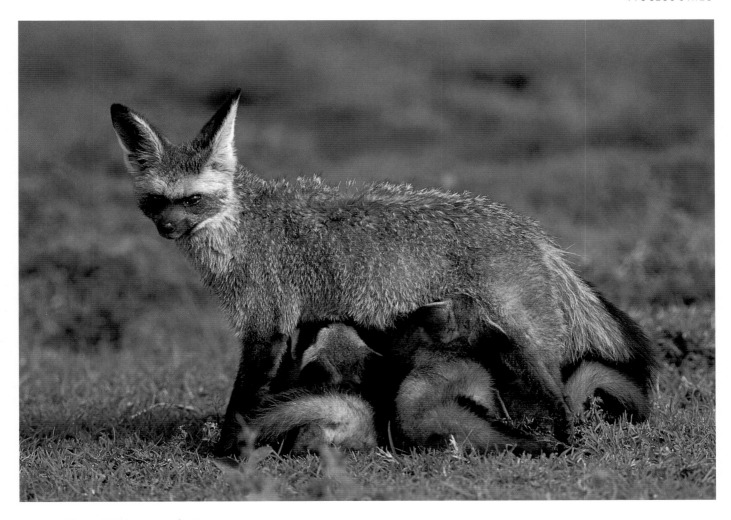

Bat-eared fox, with three month old pups.
Masai Mara, Kenya.
Nikon F4, 600mm f/4 lens, Fujichrome
Sensia 100.

pictures to his host, who exclaimed 'What a wonderful camera you must have!' The following day the host went out pheasant shooting.

On his return he proudly displayed his day's bag. The photographer exclaimed 'What a wonderful gun you must have!'

How much weight will you have to carry?

Here are three possible packs:

PACK 1	
Camera body	1.0 kg
Telephoto lens 400 mm f/5.6	1.5 kg
Linhof Ball head II	0.5 kg
Manfrotto tripod	2.5 kg
Total	**5.5 kg**

PACK 2	
Camera body	1.5 kg
Telephoto lens 500 mm f/4	3.0 kg
Studioball	1.5 kg
Gitzo 340 tripod	3.0 kg
Total	**9.0 kg**

PACK 3	
Camera body	1.5 kg
Telephoto lens 600 mm f/4	6.0 kg
Tilt head 116 Mk 3	3.5 kg
Gitzo 500 tripod	4.5 kg
Total	**15.5 kg**

I would personally draw the line at a 500 mm lens. The weight and bulk of a larger lens makes wildlife photography a chore instead of a pleasure. If you don't have to make a living out of nature photography, you don't need a lens of greater focal length than 500 mm.

EXPOSURE TECHNIQUES

Using flash

Flash technology has progressed substantially in the past few years, and most SLR cameras now incorporate through-the-lens (TTL) flash metering and control. Don't confuse this with autoflash, in which a sensor in the flash unit monitors the light. This is nowhere near as accurate. TTL flash metering is monitored inside the camera body, as its name suggests.

In addition to TTL metering. the internal reflector panels of the better portable flash units can be altered to give a field of light that closely matches the angle of view of the camera lens in use. This results in a more efficient use of the light output, and allows the flash to be used over much greater distances. This facility is particularly useful with zoom lenses, as the field of illumination can be matched to the focal length in use.

Although the new flash technology simplifies the work, it still needs to be used with intelligence. I can illustrate this with a story from my own experience.I had been working in the Masai Mara in Kenya, trying to photograph a leopard family, a mother with two cubs. I had followed them with my camera for many months. My base camp was at the Mara River camp grounds. Each evening a few pieces of fruit were put out on a tree stump to entice out another photogenic subject, namely bush babies. As it was totally dark, photographing them was going to be quite a challenge.

A spotlight made it possible for the people in the camp to see the bush babies who had, over the years, become accustomed to this nightly routine. Naturally, I didn't wish to miss the opportunity to photograph these nocturnal

Left: Baboon, Lake Manyara, Tanzania.

Right: Hoary Marmot, Olympic National Park, USA.

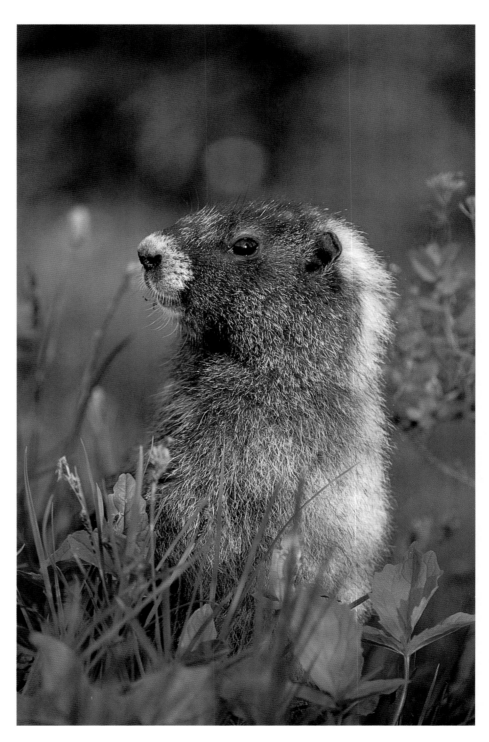

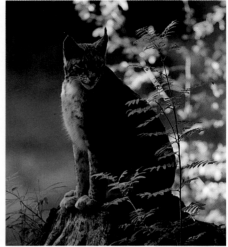

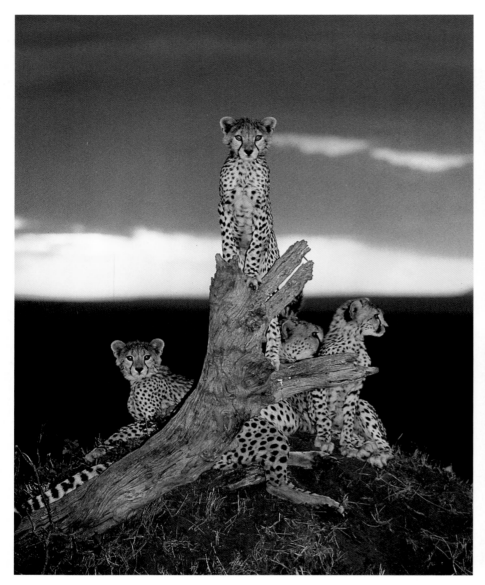

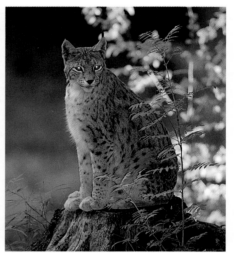

primates. They were not at all shy, and allowed people to get as close as five to ten metres. This meant that I could use my flash with a fairly high-speed film to capture their image. I put a Nikon SB-24 flash unit on my camera, switched to the AF mode and started to shoot. The finished slides were useless. The dark animals had blended into the black background and were almost invisible.

On my next trip I took a powerful Metz flash unit, with its tele-adaptor as a second flash. This unit I placed behind a tree and slaved to fire simultaneously with the SB-24 on the camera to add backlighting. I hoped this would outline the dark animal and make it stand out from the black background. These pictures also turned out to be useless. The autofocus on the camera had not worked well, presumably because

the spotlight on the tree was not bright enough. Exposures, too, varied greatly. Presumably 9 m distance was too great for the measuring light of the SB-24 to operate effectively in TTL, even at an aperture of f/2.8. The TTL metering was also probably over-sensitive to the position of the bush baby and, perhaps, to the circle of bright light from the second flash unit.

I had a third try on my next visit. This time I switched my flash unit to 'manual' and my lens to manual focus. The flash guide number indicated an aperture of f/8 with Ektachrome 200 film, but I opened up to f/4.5. (Guide numbers are calculated for lightish subjects such as humans in bright reflective surroundings.) So there I was, the correct aperture set manually, the focus set manually on the correct spot, and all I had to do was wait. In this unusual situation all

Top: Lynx in strong backlight on a bright, sunny day.

Above: Fill-in flash used at full power (here, the glowing eyes are undesired!). 400 mm f/3.5 lens.

Above left: Female cheetah and her young at dusk. Masai Mara, Kenya. 100–300 mm f/4 lens, Kodachrome 200, car window support. Open aperture, timed release, metered against the sky and stored with the automatic exposure control button. The SB-24 flash was fired at full power and the flash head focused for 85 mm and end-exposure synchronised.

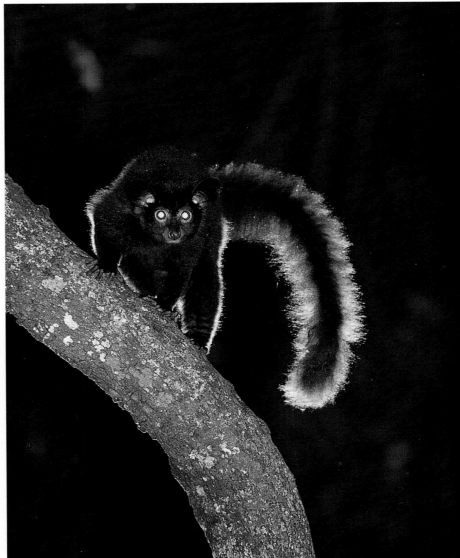

Top: The feeding place for bush babies in the Mara River Camp. Almost every night three to five bush babies would come out of the trees to fetch the fruit left for them. In this test shot the second flash is clearly visible as well as the halo of light it casts around the animal.

Above: Taken with just an on-camera flash. The dark animal blends into the black background.

Above right: The desired result, with backlighting from one flash to outline the subject and the main light on the camera. The glowing eyes could have been avoided by setting up the master flash about a metre away from the camera axis. Here I wanted the reflection from the eyes to produce the impression of a mysterious nocturnal animal. 300mm f/4 lens used at f/4.5 at 9m distance; Kodachrome 200, tripod, Nikon SB-24 as master flash and Metz 45 with tele attachment as backlight f/4.5 at 9 metres.

the automatic controls were actually conspiring to ruin the shot. Disconnecting both and working from experience did the trick. Oh, by the way, the patience was an integral part of the exercise – I had to wait a total of 20 hours before I got my shot!

Fill-in flash techniques

It's often said that the biggest problem a nature photographer faces is not the equipment but the dependence on environmental conditions. A painter can be inspired by nature, but ultimately produces a painting from a mental image. From a different point of view, though, the outstanding characteristic of our medium is that we do capture reality, not just by reproducing it, but by combining perspective, illumination, composition and

an instant of time into an impression of that reality.

Most nature photographers are constantly seeking new tools that will enable them to utilise more hours of the day for making images. The modern electronic TTL flash has helped to do this. But apart from simply supplying illumination when there is insufficient ambient light, today's portable flash units have two other important capabilities. One is the choice of front-curtain or rear-curtain synchronisation; the other is automatic fill-in capability (i.e., balanced illumination of the shadows).

At one time all flash units were synchronised to fire at the instant the shutter became fully open, no matter how long the subsequent exposure. The new alternative, firing at the instant before the

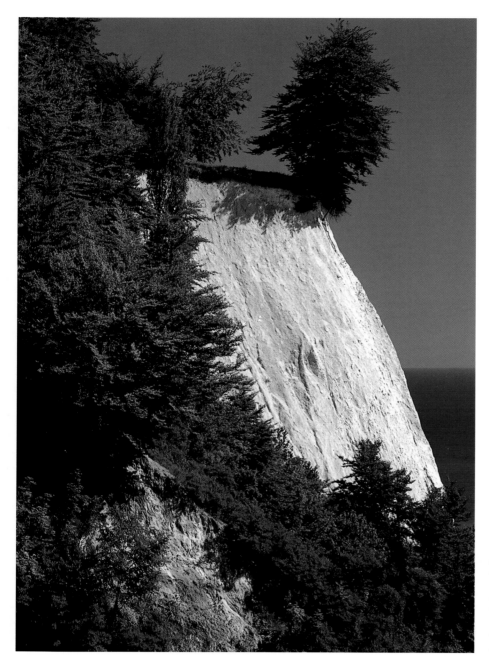

This picture of the chalk cliffs on the Isle of Rugen is a good example of a scene where automatic exposure control fails. The meter showed $^1/_{60}$s for the sky, $^1/_{45}$s for the water, $^1/_{20}$s for the trees and $^1/_{125}$s for the cliffs themselves. What kind of a slide would result with matrix metering? For a thinking photographer, though, the situation is quite simple. The main subject is the chalk cliffs. It is certainly a whole stop brighter than middle grey, which puts the correct exposure at $^1/_{60}$s. And in order to add texture to the cliffs, one would bracket $-^1/_3$ and $-^2/_3$ stop. 80–200 mm f/4 zoom lens, Fujichrome Sensia 100.

rear curtain begins to close, has several uses. One is when you want to use TTL metering for a long exposure (more than 1/30 s). Some cameras will not make exposures longer than 1/30 s in the 'front' mode, no matter how long the set exposure. Switching to 'rear' mode allows you to make an exposure as long as you need before the flash operates.

Another use for the 'rear' mode is in high-speed action photographs, such as birds in flight. With a normal flash setting, any blur (from the continuous ambient light) will be in front of the subject, giving the odd impression that it is flying

backwards. In the 'rear' mode any blur will be behind the subject, resulting in a natural appearance and the impression of forward speed.

For photographs such as the cheetah mother and her cubs, which called for well-balanced lighting from both available light and flash, I adopted a simple technique for determining the right balance. I always try to keep things simple because in nature photography one's attention needs to be on the subject at all times. I pointed the camera towards the sky and took the first meter reading, pressing the exposure lock button on the camera to hold this exposure

setting. Then I pointed the camera at the subject in the scene, and pressed the shutter release button with the flash set on 'rear' for the proper fill-in exposure. The shutter remained open for the available-light exposure based on the metered sky, and at the end of this exposure the flash fired to give the correct fill-in exposure. All this was done in a few seconds, achieving a perfect light balance by the simplest possible method. In this case (unlike the bush baby example) I was able to exploit the advanced technology built into the camera and flash.

One of the most useful times to use

Lupins, an easily-metered subject, because none of the areas in the scene differs greatly from middle grey. Experienced photographers know that the green hues of the outdoors are rendered somewhat too bright on slides, and shoot an additional slide with a compensation value of −1/3 stop. 200 mm f/4 macro lens, Fujichrome 100 pneumatic release.

fill-in flash is when the quality of light falling on your subject is less than ideal, for example at high noon in the tropics, when the contrast between highlights and shadows gives a harsh impression and it is impossible to take a satisfactory photograph by available light. Backlighting is another problem because, while the lighting effect overall may be interesting, even dramatic, it will render the animals' eyes lustreless and the faces dark. In such situations fill-in flash can work wonders, especially when it is used in a subtle way, as in the picture of the leopard. Only an expert could tell from the tiny catchlight in the eye that fill-in flash was used here.

Depending on the brightness of the fur or the features of a subject, you should set the fill-in flash (not the camera) to deliver two to three stops of light below the ambient light level. Such a weak fill-in is also suited to wintry scenes as, for example, at a feeding area where there are likely to be strong shadows. A weak fill-in flash can add sheen and texture to the feathers and fur of the subjects under an overcast sky, so that they no longer appear dull and grey, without its being apparent that flash was used. I always carry a flash so as to be less dependent on the environment and to have creative freedom under a variety of lighting situations.

Testing and calibration of equipment

You can invest in good equipment and follow careful procedures, such as mounting the camera on a tripod, taking exposure readings from a grey card and exposing using a cable release, and still find that the results aren't as good as you expected. The transparencies may be slightly overexposed or underexposed, or the colours unsatisfactory, the contrast low, and so on. This could possibly be your own fault, but it may not be so. Cameras and lenses come from an industry based on assembly line production. Millions of SLR

cameras and lenses roll off these production lines every year, and in spite of rigorous quality control (especially with the biggest manufacturers), there are differences in the way similar equipment performs. It is thus a good idea for you to take the time to calibrate your equipment. The first thing you need to establish is whether the meters in different camera bodies are giving the same results. You can easily do this by taking readings off a standard 18% reflectance grey card using the instructions that come with the card and checking the results against actual exposures. If a camera body meter isn't reading correctly, send it for-servicing – under its guarantee,if that is still valid.

Next, check all your lenses for variations in exposure. under uniform illumination, set shutter priority and centre-weighted integral metering, and shoot seven slides of the grey card with each lens, going from +1 stop overexposure to -1 stop underexposure in $1/3$ stop steps, using the exposure compensation control on the camera. You now have seven slides where (supposedly) the middle slide is correctly exposed, bracketed by three each side, one side underexposed and the other

overexposed. If you are testing, say, five lenses and have five strips of seven exposures, place them next to one another on a light table or on a piece of white card. Align the exposures that show exactly the same density. if all the strips are aligned, you are lucky: all the lenses are operating correctly. If you have had to move one or two out of alignment in order to line up the identical exposures, you will be able to see which lenses are not exposing correctly, and how much compensation will be needed. Among my own lenses there is a 400 mm f/3.5 lens which underexposes by 3 stop and a 70–200 mm f/2.8 which underexposes by $2/3$ stop, so this is not a trivial matter.

Test the teleconverters in a similar manner, and don't be surprised to find different results with different lenses. For example, my X1.4 AF converter is excellent with my 300 mm f/2.8 AF lens, but when used with my 600 mm f/4 AF telephoto, it overexposes by $2/3$ stop so that I have to set the exposure compensation control to $-2/3$ stop.

Next, check your favourite films. Change the camera's automatic exposure control in increments to find which setting

Alpine aerial view, Bavaria, Germany. Nikon F4, 50-135mm f/3.5 lens, Fujichrome Sensia.

Marmot in the Olympic National Park, Washington, USA. A very simple scene, but the automatic exposure control fails to give the correct setting. Integral metering would render the slide too light because of the dark band of trees in the centre of the picture. Multiple field metering would fare no better as it would not take the bright sky sufficiently into consideration. A grey card and spot metering, an incident light meter or the 'rule of f/16' would give the correct exposure. 28-85mm f/3.5-4.5 zoom lens, Fujichrome Sensia 100.

gives the best exposure. Make the necessary corrections to the ISO speed setting you use for that film. For example, I have found that I need to use an ISO 40 setting for Fujichrome Velvia ISO 50, and ISO 250 for Kodachrome 200. I make this adjustment by setting the camera's exposure compensation dial to $+^1/_3$ with the Velvia and $-^1/_3$ with the Kodachrome.

When you are examining different brands of slide film for the correct ISO speed setting, use the same criterion for your personal choice as in the lens testing for exposing and analysing the film frames. If you use more than one processing lab, do a comparative test with them, too. Expose five or six slide films of the same emulsion batch under the same lighting conditions, with the same subject and lens in the same camera body, and send them to the different processing labs. Don't be surprised if the results look different. Pick the lab that has produced the result closest to your taste and stick with it. Incidentally, this applies even more strongly to negative-positive processes.

There are certainly subtle differences in the E-6 transparency developing process as carried out by different labs. I know of

photographers in Germany who always used to send their Fujichrome 50 films (which are a bit on the cool side) to a particular lab in Stuttgart, because it produced a warmer balance than other labs.

Test the colour output of your electronic flash unit too. The easiest way to do this is to simply photograph a grey card and match it against a normal daylight shot. My SB-24 is neutral, whereas my SB-25 gives a yellowish cast. I was able to balance out the yellow hue by fixing a weak blue filter to the front of the flash.

As a rule, exposure deviations in cameras, lenses and films are minimal and, if you are lucky, will cancel one another out. But occasionally the errors add up. If a camera shows a $-^1/_3$ stop deviation, the lens a $-^2/_3$ stop deviation, and you use Elite 50 film with its $-^1/_3$ or $-^2/_3$ stop deviation, your total deviation is $-1^1/_3$ or $-1^2/_3$ stops, by no means a negligible error. That is why you need to calibrate your equipment, and if you can't make a simple compensation you should return the offending item for servicing.

Great Crested Grebe on nest, a chick is sleeping on its back.

How to expose correctly

A group of nature photographers was standing in Denali National Park in Alaska photographing a most beautiful scene. A caribou was in the foreground; behind it, Wonder Lake shimmered like a mirror in the light, and the majestic snow-covered mountains formed a backdrop. All were seasoned professionals. After the caribou moved on, nobody even mentioned the beauty of the scene. The only topic was 'What exposure did you give?'

If you are working with colour negative material, this section won't be of much interest to you. You can simply set the automatic exposure control on your camera and forget about it, except for the most unusual lighting situations. Modern colour negative film has enough latitude to cope with two to three stops of overexposure and at least one stop underexposure without noticeable degradation of print quality, unless you are intending to make very large prints. Any serious colour errors or bad tones are likely to be the fault of the lab rather than your incorrect exposure. But for transparency material it is a different story. Even $1/3$ stop error can take the edge off an otherwise excellent transparency.

How to expose correctly

How is it possible for us to control the camera's function of setting the correct exposure? What are our choices of the way the aperture and shutter speeds are set and the way the meter measures the light for a given scene? (The discussion below

assumes you are using a camera model with programmable exposure.)

Manual mode

The most basic camera exposure mode is 'manual'. Neither the aperture nor the shutter speed is controlled by the camera. You have to set both based on what the camera (or a hand-held) exposure meter indicates. I use this approach mainly when employing the mirror lock-up, as this is only possible in manual mode. Otherwise. manual operation is too slow. In addition, in manual mode you have to be alert for changes in the illumination which make it necessary to re-meter and then readjust the camera controls. More serious, manual control can inhibit your paying full attention to the subject matter.

Program modes

These are forms of full automatic metering in which the camera chooses a combination of shutter speed and aperture. There are two basic programs. In the 'P' program, at the lowest light level the aperture is wide open and the shutter speed appropriately low. As the light increases both the aperture size and the exposure time are progressively decreased until at the maximum illumination both are at their minimum setting. This type of program is standard on cheap compact cameras, but is only suitable for casual photography where depth of field or

Above: A separate exposure compensation dial, such as that provided on the Nikon F4 and the Canon EOS-1, simplify exposure adjustments, compared with those where you have to run through a menu on an LCD display.

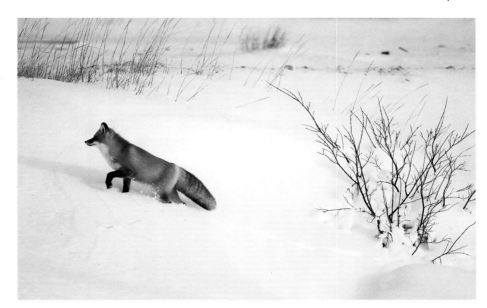

Red fox in fresh snow. Hudson Bay, Canada. A wonderful subject, but a difficult metering situation. The fox appeared suddenly from behind a snow drift. I had to attach the lens to the ball head, fasten it to the car door, focus, compose the scene, meter it and set the exposure – too much to do! So I said to myself, 'the subject is somewhere between bright and very bright, set the compensation dial to +1⅓ stops, use autofocus and press the autofocus lock.'

Above: A hand-held light meter is better than a built-in meter, which measures only the light reflected from the subject matter. An incident-light meter reading shows how much light is falling on the subject – much more relevant to slide film.

stopping of motion is not a primary concern. In the 'PH' program, as the illumination increases only the exposure time is reduced, until the top shutter speed is reached, after which the aperture is progressively closed down. There is also a complementary program available on some cameras with a corresponding bias towards small apertures.

Shutter priority

In the shutter-priority mode you can select the desired shutter speed, and the camera's computer will find the appropriate aperture setting. At first glance this may seem a good candidate for a universal exposure mode, especially for action photography, where the critical factor is the freezing of movement. But there is an important limitation to this mode. The problem occurs when you have set a fast shutter speed and the lens aperture is already wide open in bright light. Then if the sun goes in your shots will be underexposed. Conversely, if you are using a fast film and you set a medium shutter speed, in a bright light the lens aperture may not be able to close down far enough to prevent overexposure.

Aperture priority

The aperture-priority mode operates in the opposite way. Here, you choose the aperture, and the shutter speed is automatically set by the camera. It is this mode which, in my experience, requires the least attention from the nature photographer and, in my opinion, makes

the best use of the camera's calculations. In cheaper or older cameras that do not have fully-programmable exposure control, this is often the only available mode. Its merits can be illustrated by two examples.

In the first situation, you want the shortest possible exposure time at full aperture, say f/4. The highest shutter speed that is available for the illumination is then automatically set by the camera. Your camera shutter has a top speed of 1/4000 or 1/8000s, so you needn't worry about overexposure if you are using a medium-speed film. This allows you to concentrate fully on the subject matter. Should a cloud come by, the camera will react by reducing the shutter speed to compensate. If, on the other hand, you had set the camera when clouds were present, and then the sun were to come out, the shutter speed would be automatically increased. In both situations you are still getting the fastest possible shutter speed that each lighting situation allows. Finally, in this mode you can always keep to an aperture that gives you the exact zone of focus you need.

Metering patterns

The next consideration is which metering pattern to use. There are three main choices: matrix, spot and centre-weighted. Matrix metering calculates exposure by measuring multiple points in the field, the values of which are analysed by the camera's computer to determine the final exposure. I don't care for this approach, as the final settings are totally under the control of the camera.

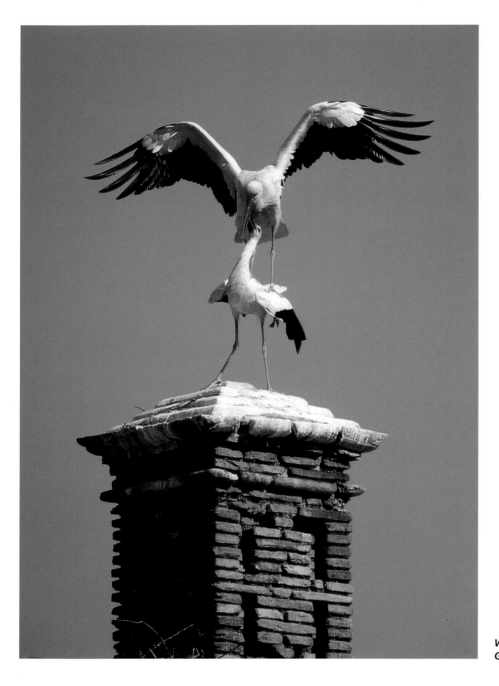

White Storks courting display, Bergenhusen, Germany. 200-400mm zoom lens.

Spot metering is popular with many professional photographers as it provides a measurement of very small sections of specific areas within the scene. The key to doing this effectively is to be able to assess which areas of reflected light represent middle grey, and accordingly, how far the other areas deviate from that middle grey. I don't use this mode very often as I find it difficult to decide exactly what spot corresponds to middle grey, especially when the subject is brightly coloured.

The centre-weighted metering pattern measures the light across the scene with a bias towards the centre. The amount of emphasis given to the centre in relation to the outer field can be between 7:3 and 6:4. This system seems to me to represent the nearest approach to the ideal, provided there is no bright sky or other obvious deviations from normal lighting. It is safe to say that a photographer can shoot well over half of all pictures with this metering pattern, leaving the remainder requiring $\pm 1/3$ or $2/3$ stop correction and, perhaps, one in ten needing a full stop correction. Apart from sky, snow, bright beach scenes or other high reflectance areas, scenes with different colours and tones will record very satisfactorily with the centre-weighted pattern.

How do I control and correct the exposure set by the camera? As I said earlier, I usually use the centre-weighted pattern. I take my wildlife shots at full aperture, usually f/4, landscapes at f/11 and close-ups at f/22. In all cases the camera provides the correct shutter speed automatically. To make sure the exposure will in fact be correct, I have to decide whether the scene in general corresponds to a middle grey, or is darker or lighter, which would then require some adjustment of the exposure. In cases of doubt, all I have to do is to substitute a grey card for

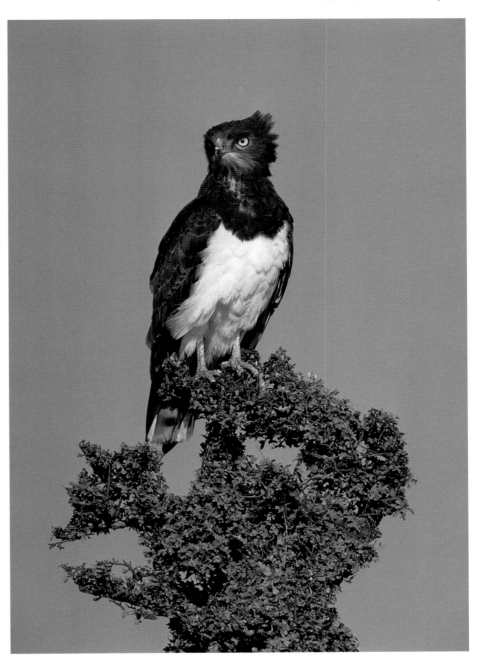

Black-chested Harrier Eagle, Masai Mara, Kenya. Nikon F4, 600mm f/4 lens, Kodachrome 200.

the subject and see if this makes any difference to the exposure setting.

I make such adjustments using the exposure compensation dial. I don't need to look at it, as I can monitor the change in the shutter speed in the viewfinder display.

Of course, there are bound to be scenes where no amount of experience can tell you for certain whether the exposure (calculated by the camera and corrected by yourself) is really going to be spot-on. Sunsets and contre-jour shots are notorious, for example. So it is no climb-down to suggest that you should adopt a belt-and-braces approach, and whenever

you have the time and film to spare, bracket your exposures. This means that if you are fairly sure your estimate is right, take two further exposures at $+1/3$ and $-1/3$ stop; if the lighting is unusual, give $\pm1/3$ and $2/3$ stops, and in really uncertain cases such as shots directly into the sun, bracket up to two stops either side. Some photographers actually close down the aperture while exposing on the motor drive, but this is very wasteful of film.

Some photographers feel that bracketing in this way is rather a defeatist approach, and I am inclined to agree. There are others ways of checking the correctness

of an exposure setting. In wildlife photography, where it is difficult to work with a grey card or a hand-held light meter because things are happening so fast, it is still often possible to alter your metering location in a scene by moving the camera to obtain a more accurate sample of the light actually falling on the subject. For example, in metering the tiny kingfisher, the camera offered me an exposure time of 1/125 s. I didn't trust the reading because most of the picture area was a very dark background. To get a more representative sample I swung the camera slowly towards the left, where the tree the bird was sitting

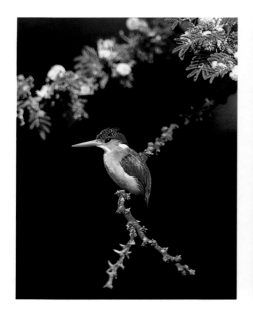

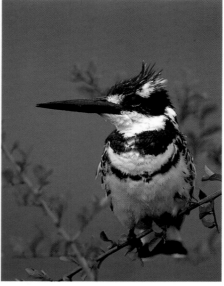

Far left: Crested dwarf kingfisher, Masai Mara, Kenya.

Left: Grey kingfisher, Masai Mara, Kenya. Both pictures 600 mm f/4 lens with X1.4 converter, Fujichrome 100, car window support.

on was bathed in sunlight. The meter reading changed to 1/250 s. This check saved the picture from being overexposed by one whole stop.

A similar thing happened with the big white kingfisher. The background appeared uniform and close to middle grey. But I wondered how the bird's bright piebald plumage might have affected the metering. So I moved the camera to the left, and the exposure setting went from 1/250 s to 1/180 s, about half a stop difference. As I felt that the background was slightly lighter than middle grey I added $2/3$ stop. The result was a perfectly exposed slide.

When you are using this method of adjusting exposures, it is important for the exposure compensation dial to be easy to manipulate. On the most up-to-date professional camera models this dial is separate, but in older cameras it may be necessary to operate a release button before you can make the adjustment. On other camera models you sometimes have to push 'function' buttons several times before reaching the function you want, and you have to check this on an LED display. This is reason enough for nature photographers not to choose such cameras.

Another very simple method for estimating correct exposure is the 'f/16 rule'. This is simply that in full sunshine, at f/16 the correct exposure time will be numerically the same as the ISO speed index of the film. Thus for ISO 125 film it would be 1/125 s. This is remarkably

accurate, and in fine weather it is reliable enough for you to be able to use it to override the camera metering where the subject matter is dodgy. The rule applies from about one hour after sunrise until one hour before sunset.

As with all meter readings, once you know one combination of exposure time and aperture, you can invoke the law of reciprocity to convert to other combinations which will supply the same exposure (i.e. total light energy). This allows you to change the settings to change your depth of field or shutter speed as necessary. Thus, 1/125 s at f/16 will give you the same exposure as 1/250 s at f/11, 1/500 s at f/8, 1/1000 s at f/5.6 or 1/2000 s at f/4. In each case, doubling or halving the exposure time will change the exposure by exactly the same amount as opening up or closing down one full stop.

Probably the worst way to meter exposure with transparency film is to slavishly follow the reflected-light method. Since this bases the exposure on the results of light that is reflected off the subject, correct exposure depends on how close that subject's reflectance comes to middle grey. When you meter an average scene, the reflected light values usually do combine to give something like the reflected light value of a middle grey card. If not, then you have to rely on the film's exposure latitude to capture what is there. Colour negative film is tolerant of exposure errors because it can accurately record a wide range of light values, and in the printing process there is the opportunity to

compensate. Slide film is unforgiving because there is no second process to correct any errors in the original.

If you know that your slide film has been consistently underexposed, your lab can compensate for this by 'push processing' it, compensating for up to two stops underexposure, the penalty being some loss of colour saturation. Slight overexposure (up to one stop) can also be compensated for, with less of a penalty, possibly a slight shift in colour balance. But the best results will always be from a correctly-exposed film.

If you meter a piece of white card, a middle grey and a dark grey card you will get three different readings, even though the illumination is the same. If you actually give these exposures, the three slides will have exactly the same density. This is plainly not what you want in a transparency film: you want the slides to show the correct tone in each case. But that is the way both in-camera meters and hand-held reflected-light meters work. Studio photographers, who work with hand-held meters all the time, invariably use them in incident-light mode. These meters have a white dome covering the photocell, and to operate the meter you place it at the subject and point it towards the camera. It thus measures the light falling on the subject, and its reading is not affected by subject reflectance. It gives the same reading as a reflected-light meter (or a camera meter) pointed at a grey card.

Although an incident-light meter is a

Despite an overcast sky the foreground, tree and rocks are sunlit requiring exposure control.

real asset for landscape work, it is of limited use for close-ups, as it doesn't compensate for the diminution of illumination at the film when you are working at long lens extensions. As this amounts to two whole stops for a 1:1 magnification, the required compensations are so large that you are better off using the camera's TTL metering and compensating for subject brightness along the lines suggested above, and using a grey card reading whenever possible. Of course, this is usually out of the question with wildlife photography. But if you are photographing animals from a hide you can paint a piece of wood middle grey, place it near the area where you expect your subjects to be, and take a reading on it every so often, or whenever the light changes.

By the way, if you forget to take your grey card along, take a reading off the palm of your hand and add one stop (your hand is a little lighter than middle grey).

You shouldn't forget that the maximum possible variation of a subject from the middle tonal range cannot exceed two stops if it is to record on the film. This limits the recordable brightness range of your subject matter to five stops, or about 32:1. However, in outdoor work this range is seldom exceeded. Even pure white snow is never underexposed by the automatic exposure control by more than two stops, and the blackest lava is never overexposed by more than two stops. So, provided the light itself is not too contrasty you will always be able to come close to the correct exposure and provide any necessary compensation.

PHOTOGRAPHING NATURE

*I wanted to learn to see, and when
I discovered Rilke I found not only a poet,
but a soulmate. He touched my soul when
he said: 'I am learning to see; I don't know
why, but everything goes deep inside me
and does not remain on the surface as it
used to do. There is something inside me
of which I know nothing, and everything
now enters it. I don't know what
happens there!'*

Ernst Haas

Photographic reality

When we visit unspoiled places without a
camera, and simply gaze at the views; we
see this special world in a literal way.
Such a concept of 'natural reality' isn't
what the photographer seeks. What we
want to capture might be called
'photographic reality'. The photographer
adds to the literal view a further
perspective through composition, light and
shade, colour balance. Photographic reality
selects an instant and isolates it. At its best
a photograph can convey the whole ethos
of the slice of Nature it represents.
The sum becomes greater than its parts.

Take, for example, the picture of the
heron and the alligator. For me it
represents the essence of life in the South
American jungle. The Amazon river makes
its way through giant forests where tropical
animals lead their mysterious existence
among huge old trees. This picture records
a saurian and a water bird; but it also fuels
the imagination. In fact, the scene was
photographed at the end of a road
through the Ding Darling Wildlife Reserve
in Florida. Here, at the end of the reserve,
the road takes a sharp left turn, and
running parallel to it is a moat, a favourite
spot for alligators. The area is almost
always full of tourists. At the time I took
this picture the very small parking area was
crammed with parked cars and people.
The noise was deafening. I had great
difficulty reaching an appropriate position
because of the crowds... Natural reality?
Among this bedlam?

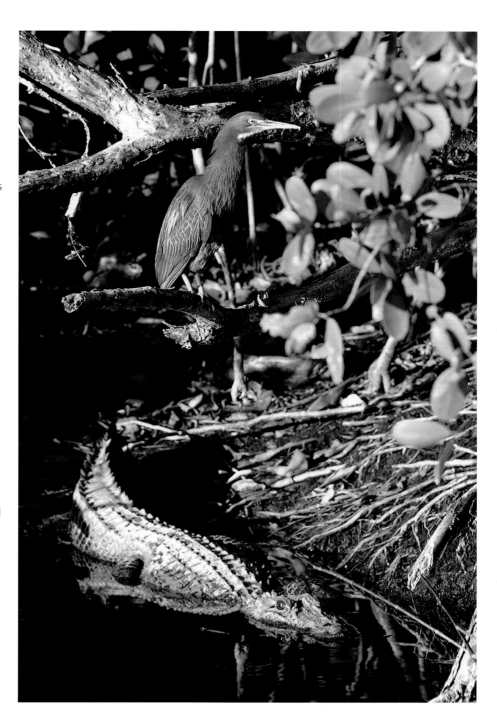

*Opposite: A completely natural scene, the
river flowing over moss-covered boulders
as it passes through the forest.*

*Above: This picture shows a scene of
untouched nature; this photograph
symbolises the solitude and secretive life
of the tropics. 300mm f/4 lens,
Kodachrome 64.*

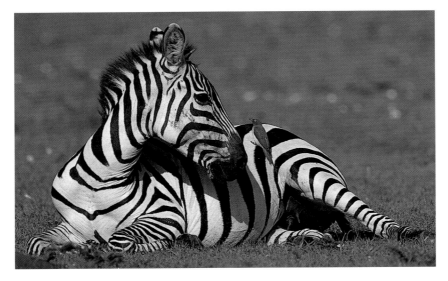

Left: Zebra and red-billed oxpecker. Masai Mara, Kenya. The symbiotic relationship between the oxpecker family and the great mammals of Africa is well known. What makes this photograph particularly effective is that the two animals seem to be looking one another in the eye. 400mm f/3.5 lens with X2 converter, Fujichrome Velvia 50, car window support.

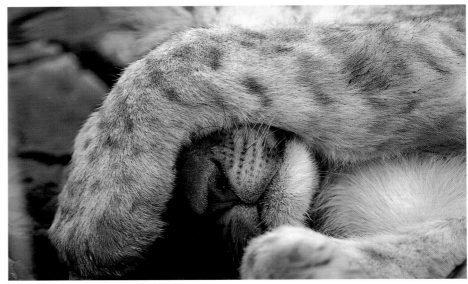

Right: This picture comes off because the carelessly flung paw reminds us of a human child's gesture.

So you see, reality has two sides, in front of and behind the camera. If you expect the serenity my picture displays to be a true representation of Nature's reality, you may be seriously misled. This image was the creation of the photographer and not the reality of that day on Sanibel Island, Florida.

Success and failure go hand in hand in outdoor photography. Such is the case with the picture of clover on a tree stump, which I took in the Bavarian Forest National Park. I had been walking for several hours through the melancholy, cloud-covered forest when I stopped in surprise. In front of me was a patch of clover a metre high, growing over a mossy tree stump. I tried for an hour to capture the atmosphere of it, but in vain. What had been a stimulating experience was tedious and moribund in the viewfinder –

an aesthetic failure.

Edward Weston said: *'Only with difficulty can one persuade the camera to lie. Basically it is a truthful medium.'* I am not sure that I entirely agree. The reason nature photography attracts – indeed fascinates – so many people is probably because of the tremendous variety of the subject matter and the different approaches possible. You can get into your car, drive to a rural area, park and then wait for a pheasant, a rabbit, or some other small creature, to appear in front of your lens. You can approach nature photography with documentation in mind, perhaps the recording, in frame-filling close-ups, of all the known species of butterfly in a particular area. Or you could photograph the same subjects with an artistic eye, emphasising their aesthetic beauty. you might wish to make a scientific

record of some of their interesting, possibly previously unknown, behaviour. Again, you might take your pictures with a view to rearranging them to make a storyline; or your camera may be no more than an excuse to be alone with Nature. To me, the most important pictures are those that express emotions or awaken emotions in the viewer. Sometimes the two-dimensional nature of a photograph erects a psychological barrier between reality and the viewer. It seems to me that the pictures that most often break through this barrier are those which seek to present some kind of emotional undertone, and to relate this to our own emotional experience.

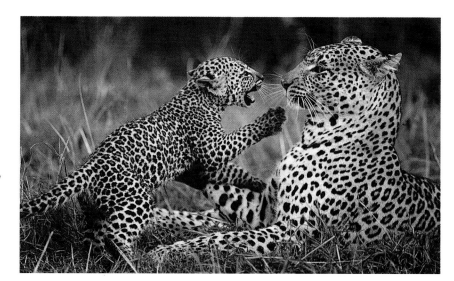

Right: This is one of my most emotion-filled images. The leopard cub is pretending to make a ferocious attack on its mother: claws, teeth, and a fierce glare; but its drooping ears give the show away. Mother isn't fooled, either. Masai Mara, Kenya. 600mm f/4 lens, Kodachrome 200, car window support.

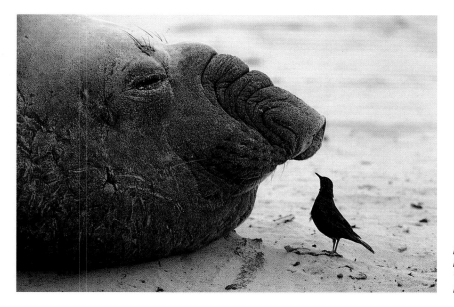

Left: Elephant seal and bird. Falkland Islands. This picture has a flavour of 'Dignity and Impudence'. 300mm f/4 lens, Kodachrome 64.

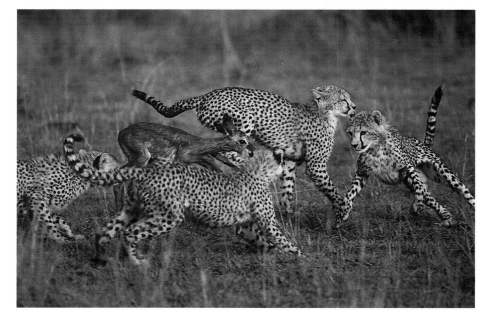

Right: Four young cheetahs and an impala. Masai Mara, Kenya. This may look like a children's game – but it emphatically isn't! 300mm f/4 lens, Fujichrome 100, car window support.

Frost flowers, X2. Bayerischer Wald National Park. 105mm f/2.8 macro lens, Fujichrome Velvia 50, pneumatic release.

Nothing is more perplexing than the truth, nothing more exotic than immediate surroundings, nothing more fantastic than reality.

Anon

Close-up photography

The actress Bo Derek played the female lead in the American movie '10', the title of which originated in the somewhat coarse practice of young American males of categorising the attractiveness of females on a scale from 1 to a maximum of 10. American nature photographers have adapted the classification to describe the quality of their images. A 10 is a photograph that cannot possibly be improved on, while a 5 is one that is just about suitable for publication. Anything below 5 is destined for the trashcan. If a colleague in the USA tells you on his return from the Galapagos Islands that he shot three 9s and twelve 8s, you know how successful he was without needing to see the pictures (provided he is telling the truth!). Naturally, we should all like to be able to consistently make pictures in the topmost categories, but life is not like that. In the three main divisions of nature photography, namely close-up, wildlife and landscape, the odds in favour of obtaining top-quality images differ. They are probably better in close-up photography than in wildlife or landscape work, largely because the conditions are easier to control. You don't have to contend with power lines hanging across the scenery, nor ugly buildings or lamp-posts, and you don't have your subjects slinking half-hidden behind bushes, or looking the wrong way, or refusing to co-operate in any of umpteen different infuriating ways. Close-up photography is tranquil: you have all the time in the world.

This freedom can be liberating and satisfying. It characteristically gives you space for your creative ideas. Mind you, close-up photography doesn't leave you any room for excuses for a poor-quality image. You can't say 'I had to act quickly' or 'It wouldn't come out in the open' or 'I couldn't get any closer'. In close-up photography there are no excuses for technical flaws or poor composition.

Perhaps the reason it is so gratifying to create an image under close-up conditions is that the image is completely under one's technical and creative control. There is no

Water droplets. Bayerischer Wald National Park. 105mm f/2.8 macro lens, Kodachrome 64, pneumatic release.

need to sit and watch for hours, or wait for just the right light. What is more, you can do close-up photography regardless of weather conditions. There is always some subject matter to find, and you don't need to travel far, either: all you need is a leaf, a branch, a patch of moss, a mushroom, a sleepy insect or a flower – virtually any small object in nature. Close-up material is literally just outside you door.

In close-up work the temptation to rearrange a flower or other subject within its setting can be strong. But a true nature lover doesn't record artificial arrangements. Your intent should be to capture nature as it is, not as you think it ought to be. I am sure all of us have at some time added little stones, turned leaves over, and so on, before taking a picture. I am against this kind of 'gardening' in principle and practice, and if you indulge in it, one day your conscience will get to you: you will realise you have been cheating, and your previously-cherished images will seem like shams.

If up to now you have photographed only animals, I do urge you to take the plunge and try your hand at close-up photography. Among other things it allows you a longer working day. It is also something to do when your animal subjects are absent or uncooperative, or the light is wrong. Balance your pursuit of action photography with the more relaxing tempo of close-up work. You will discover a totally new photographic world, with new ways of expressing your creativity. Welcome to the club!

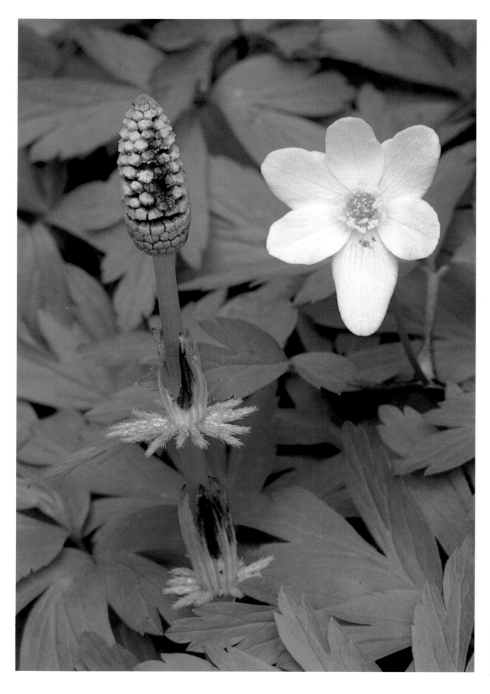

Wood anemone and horsetail x2.
Bayerischer Wald National Park.
200 mm f/4 macro lens, Fujichrome 100,
pneumatic release.

To photograph Nature is to experience it
at first hand.

Anon

Landscape photography

There are days when the nature photographer feels that nothing is going right, and life is just a bad dream. But then comes a perfect day when everything falls into place. Technical success is matched by creative success. At this time there seems to be a complete union between you and the camera, the subject, and, to be whimsical, the universe. It is for these moments of ecstasy that nature photographers endure endless hours of frustration and tedium. These moments of fulfilment can also happen in landscape photography, when scenes with intriguing lighting and fascinating colour appear out of nowhere. They are also, inevitably, a challenge for the photographer, for they are fleeting and must be captured immediately – and with the correct exposure.

Nature offers an endless selection of wonderful landscapes; but you have to work at the framing and composition to make first-class pictures from them. There are no real rules for a 'correct' composition. If there were, landscape photographs would all be drearily similar. But there are some simple guidelines to assist the beginner. The first is framing. Try to frame your foreground with branches, twigs and shadows to guide the viewer's eye to your main theme within the scene. Try to avoid straight lines: a straight line is lifeless. Curved lions lend a more dynamic quality to the composition.

As to the way you place the subject matter within the frame, a good approach

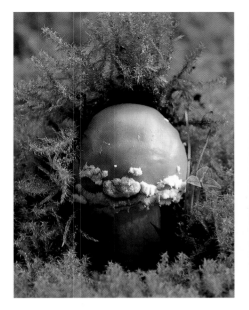 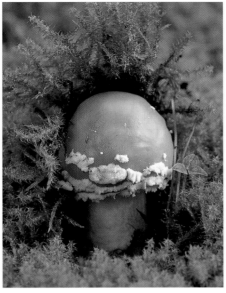 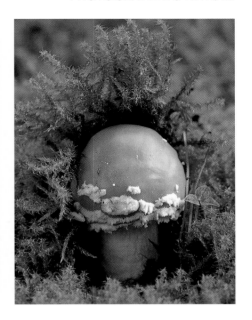

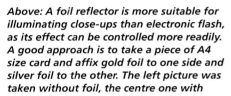

Above: A foil reflector is more suitable for illuminating close-ups than electronic flash, as its effect can be controlled more readily. A good approach is to take a piece of A4 size card and affix gold foil to one side and silver foil to the other. The left picture was taken without foil, the centre one with

silver foil, and the one on the right with gold foil (note the way the illumination of the stem of the mushroom changes). The effect of this brightening can be fine-tuned by changing the angle of the card. 200 mm f/4 macro lens, Kodachrome 25.

Above: The cone of a spruce in a mountain creek. Close-up photography is an apt medium for symbolising aspects of one's inner self. 80–200 mm f/4 zoom, Fujichrome 100, pneumatic release.

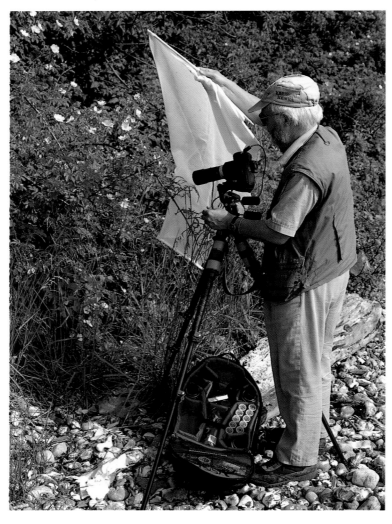

Above: This picture shows the shooting set-up on Rugen Island. A diffuser softens harsh sunlight, allowing softly illuminated close-ups on bright, sunny days.

Left: The image on the left was shot in full sunlight, which resulted in hard shadows and an uneven image. The picture on the right was taken with the sunlight diffused by a piece of white cloth.

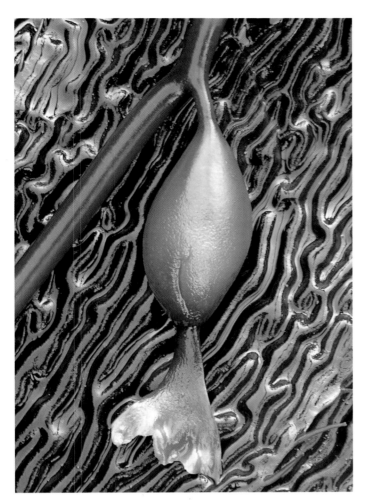

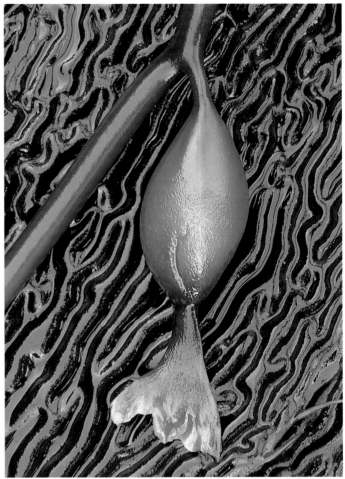

Above: Seaweed along the coast. Both pictures were taken in direct sunlight. For the image on the right, however, the light was diffused through a piece of white cloth. 200 mm f/4 macro lens, Fujichrome Sensia 100, pneumatic cable release.

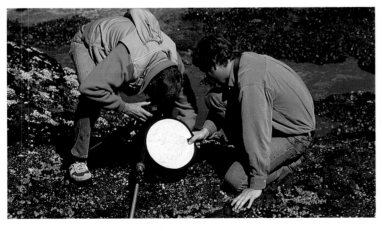

Two colleagues are photographing shells at the beach. To eliminate hard shadows, they are using a partially transparent foldable reflector (Hedler or Lastolite). In the right picture one of the photographers is taking a meter reading from the other's hand.

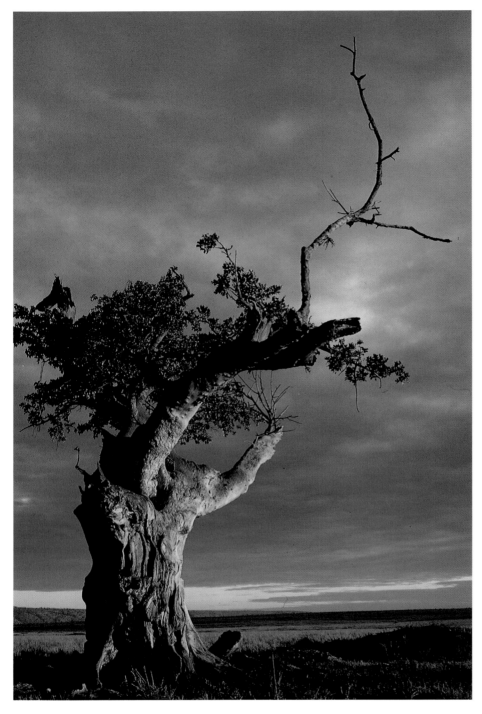

An old tree in beautiful light about ten minutes before sunrise, composed according to the golden section principle. 35mm f/2.8 lens, Kodachrome 64, pneumatic release.

is the use of the time-honoured 'golden section'. This notion is part of Western civilisation's cultural history, and has served as a unifying thread from ancient Greece through the Renaissance to the present day. It is based on the division of a line such that the ratio of the smaller portion to the larger is the same as that of the larger portion to the whole, a ratio of approximately 1.62:1. This is close to the aspect ratio of the standard 35 mm frame. If you divide this frame into thirds

horizontally and vertically this will result in ratios close to the golden mean. The four points at which the lines intersect are called 'strong points'. If you place your main subject matter at any of these you will usually get the most satisfactory composition. This 'rule', however, is not written in stone, and is certainly open to interpretation. But it can be a great help. The arrival of autofocus has led many beginners to place the main subject smack in the centre of the frame. (History

repeating itself: the same thing happened in the 1930s, when the coupled rangefinder with its central split-image spot was introduced.) Later, when focusing screens became less dependent on this centre spot, compositions improved and the 'rule of thirds' came into its own again. But we still see far too many pictures with the main subject right in the middle, with no attempt at a dynamic, unified composition.

An unusual composition with strong diagonals.

The golden section right and the rule of thirds far right are a guide to composing a photograph.

Right: Landscape photograph in Rugen.
Photo: Gisela Pölking.

Left: After sunset. 100–300 mm f/4 zoom lens, Fujichrome 50.

Opposite: Varied treatment of the same subject at the same time of the day (sunrise), but from different directions. Top, facing the sunrise, bottom, looking away from the sunrise. 24 mm f/2.8 lens, Panther 100, pneumatic release.

Right: Thistles and birch trees. 80–200 mm f/4 zoom lens, Fujichrome 50.

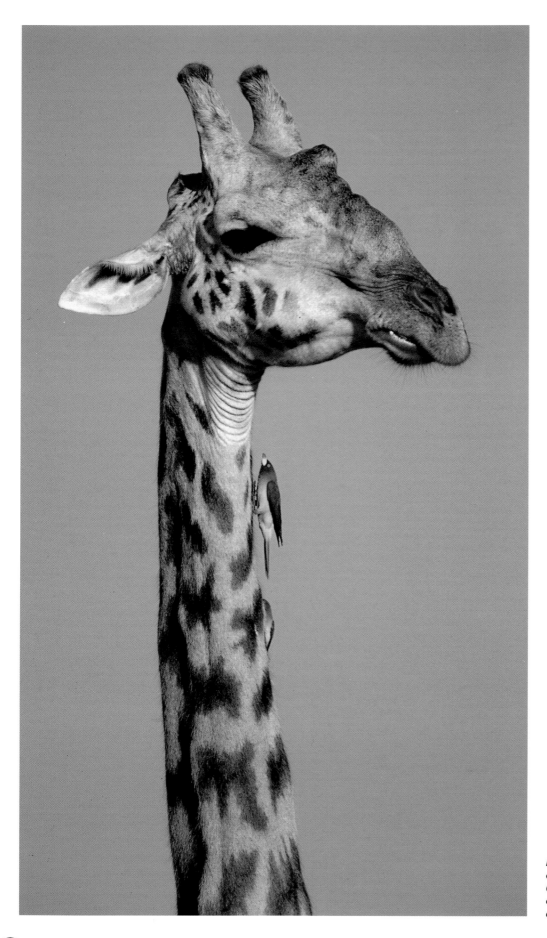

Left: Giraffe and yellow-billed oxpecker, Masai Mara, Kenya. 600mm f/4 lens with X1.4 converter, Fujichrome 100, car window support.

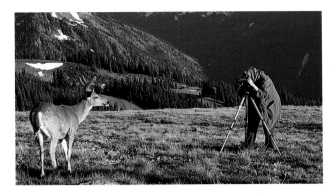

Left: An outdoor photographer at work in the Olympic National Park, Washington, USA. These animals live free and undisturbed in the vast areas of the National Parks and are not the well-fed kind one finds near visitor centres.

Below: American alligators in the Everglades National Park, Florida. A plentiful yet truly wild animal.

A true wildlife photographer has a few top-quality images which will be remembered – and the rest of the time, when he is not out on photographic projects or working on a portfolio, he just tries to get by. Others call it their life.'

Anon

Animal photography

When you decide to stalk large animals with a camera as a kindlier form of hunting, you set quite a task for yourself. Wild animals are shy, and it is by no means easy to capture them in a frame-filling image. That is why many of the pictures of fallow and red deer, wild boar etc. that are published in hunting and other magazines are not taken in the wild but in game reserves. They are not strictly natural photographs, but substitutes. In some cases the animals are tame. I remember some spectacular pictures of a fox which appeared in almost all of the German hunting magazines some years ago. They were taken on the photographer's Sunday strolls, and the fox was a pet one that would run alongside him.

Genuine wildlife avoids human contact for self-preservation reasons, having been hunted for centuries. The most trusting members of every species must long ago have been culled by ancient hunters, so that only the wary ones have survived. Thus it is difficult to get near a truly wild animal. But to the true nature photographer these difficulties merely add to the intrinsic value of the final photograph.

Today there are only a few areas left where large wild animals roam free. The specialist wildlife photographer must therefore go to places such as the wilder parts of Africa and North America. Even there, the wild animals are not so shy, and as hunting is banned in the National Parks

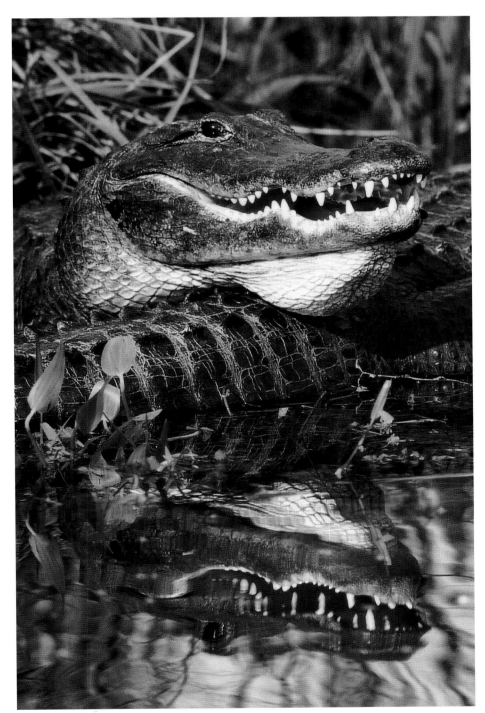

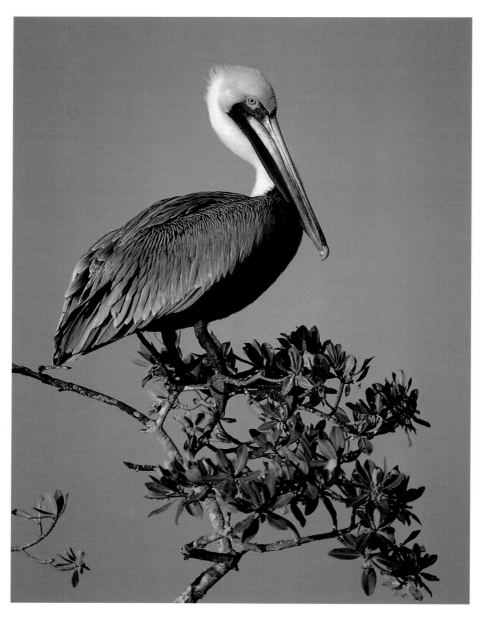

Above: Brown pelican, Sanibel Island, Florida. 500 mm f/4 lens, Kodachrome 25.

Right: Baboons at dusk, Masai Mara, Kenya. 600 mm f/4 lens, Fujichrome 400, car window support.

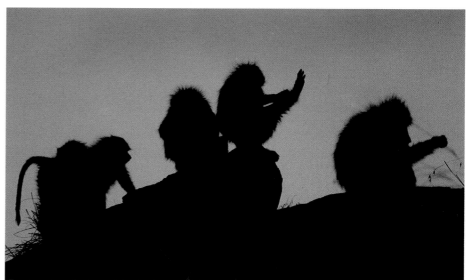

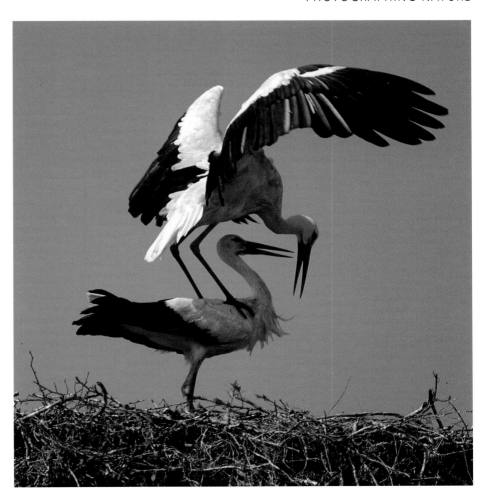

Right: White storks on the nest, Bergenhusen, Germany. 200–400 mm f/4 zoom lens, Fujichrome 100.

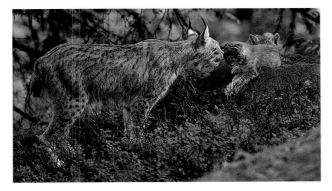

Left: Female Lynx and her young, game reserve, Bayerischer Wald National Park. Almost all of the images which appear in wildlife magazines are taken under controlled conditions. 400 mm f/3.5 lens, Kodachrome 200.

they have learned over the decades that they have nothing to fear. So in the USA you are not limited to a quick shot before the animal takes fright and flees, but can wait calmly and observe, find a suitable backdrop, consider the lighting and the perspective, and release the shutter only when you are satisfied the composition is right.

In Africa the animals are more timid. Even lions will turn in panic and run away if they see a Masai tribesman. But you can approach most animals if you are in a vehicle. There are no ditches or fences,

and the wild game in that part of the world is almost oblivious to cars and other vehicles. in some places you can almost drive over a wild zebra's foot before it will move aside. This makes it comparatively easy to document their behaviour.

The most generally popular wildlife subjects appear to be birds – at least, they predominate at competitions and slide presentations. Of course, birds are ubiquitous. There are also very many different species, and some have dazzlingly brilliant plumage. Birds also offer a wide variety of fascinating behaviours, especially

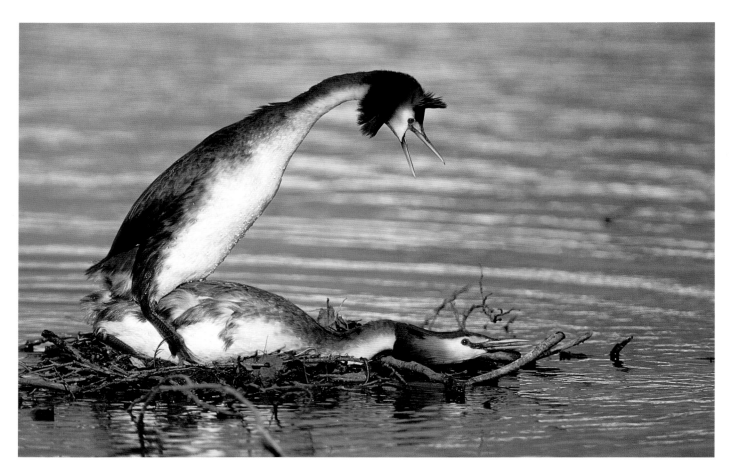

Above: Mating crested grebes. Annateich, Hanover. 500 mm f/4.5 lens, Kodachrome 64.

during mating periods. There are several ways to try your luck in this type of nature photography, from a winter hide near a feeding place to a camouflage tent near the nest. There are also opportunities near lakes and estuaries, in woods, even throughout cities, where they are accustomed to humans. You can even photograph them with a long-focus lens from a car window.

There is a strong temptation to photograph birds on the nest, and this practice has led to a good deal of criticism from nature lovers. To keep a sense of proportion, however, fewer than one out of ten such photographs will have caused any disturbance to the birds. But it is those that cause all the trouble, when nests are abandoned. So be extra careful and considerate when you undertake this type of nature photography.

One area of animal photography that is largely – and unjustly – neglected is the photography of small mammals. There are

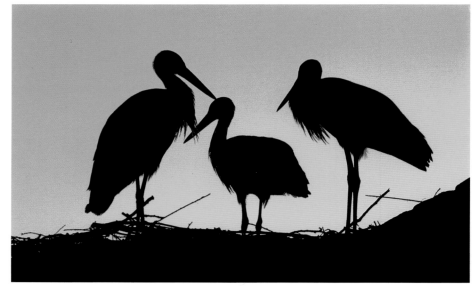

very few specialists in this area, possible because you need to know a great deal about the habits and behaviour patterns of the different species before tackling the photography of such small and mostly secretive creatures.

Above: White Storks, Alfaro, Spain. World capital of the white stork.

Opposite top: Great Crested Grebes on nest with young.

Opposite bottom: White Storks on nest.

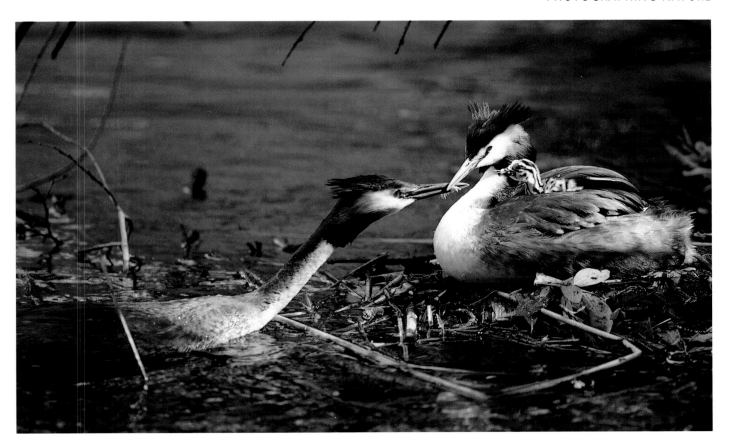

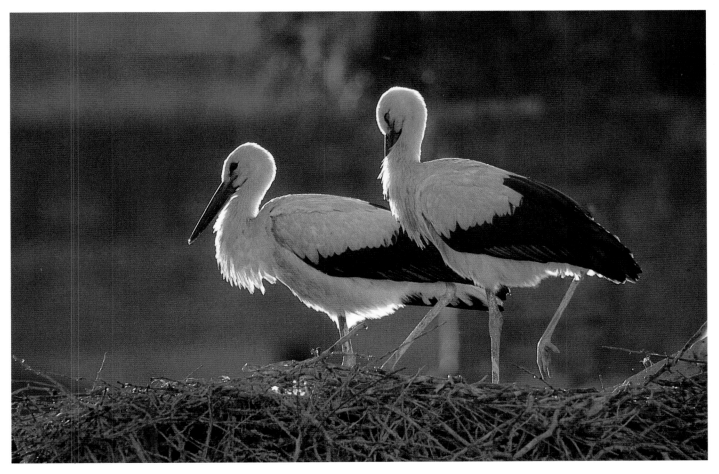

THE STORY BEHIND FOUR PHOTOGRAPHS

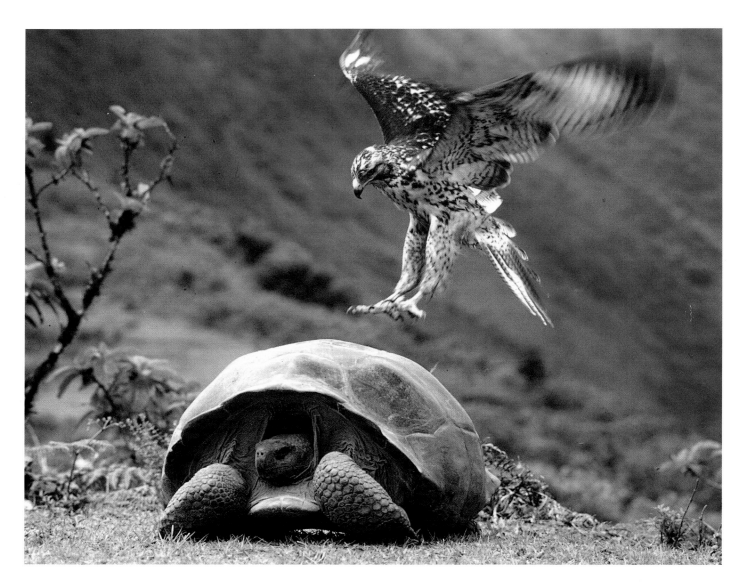

Galapagos buzzard and giant tortoise. Alcedo Volcano, Galapagos. 200mm f/4 macro lens, Kodachrome 64, hand-held.

Tortoise and buzzard

I must have taken tourist groups to the Galapagos Islands more than fifteen times. One scene from this Pacific Garden of Eden has always haunted me: the sight of buzzards sitting on the backs of the giant tortoises of the islands. Photographers such as Tui de Roy, Tittje de Vries, Udo Hirsch and the late Dieter Plage had already photographed them, on the slopes of the volcanic Mount Alcedo. The difficulty was that to reach the area one had to climb for some eight hours, then cross lava fields in equatorial heat lugging camera equipment, a tent, water and provisions for several days. At a time when I had two months to spend on the islands I managed to arrange the trip with a companion. We had to stay up there for ten days; but it was worth it in the end: I captured one of my most successful images.

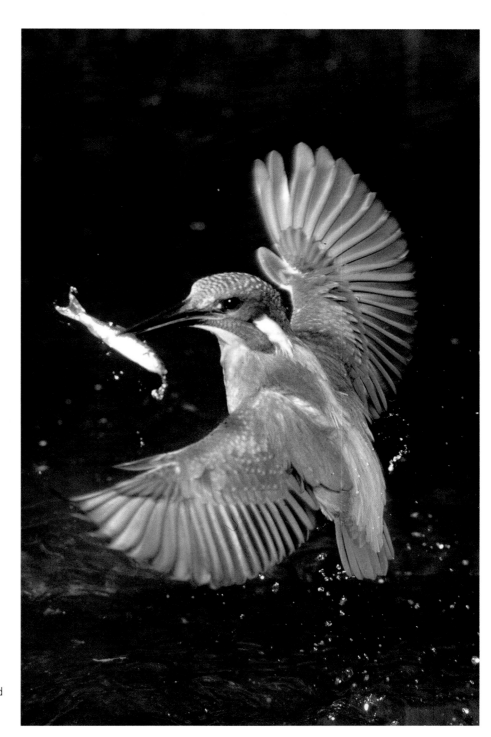

Kingfisher and fish

For six summers I had been photographing
kingfishers in the Münsterland, and the
idea of photographing a kingfisher
emerging from the water with a fish in its
beak had become something of an
obsession with me. This was one of the
first pictures I took that had been fully
planned in advance, and thus represented
something of a milestone in my career, an
advance from a hunter with a camera to a
genuine nature photographer. I had to
make a great many exposures before
I caught the right moment, with the spread
wings, the head position and the fish in a
harmonic whole.

*Kingfisher in Münsterland. 6 x 9cm camera,
240mm f/5.5 lens, Ektachrome 23DIN, (6 x 9
rollfilm), flash at ¹/₈₀₀₀ s.*

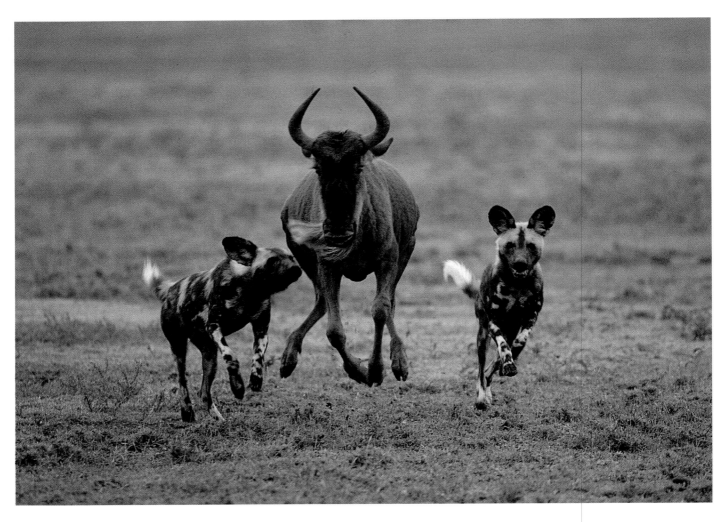

Wild dogs chasing wildebeest, Serengeti National Park, Tanzania. 300 mm f/4 lens, Kodachrome 200, hand-held.

Wild dogs and wildebeest

I could spend hours relating instances where I have managed to ruin a picture for some reason or other. It is unbelievable how many things can go wrong: the wrong film; the wrong lens; the wrong timing of the shot; failure to appreciate the situation; or just looking in the wrong direction when something was happening. One of the most frustrating situations is when everything happens while you're in the middle of changing films.

But sometimes luck is with you. On this occasion I had just finished loading the camera fitted with the 300 mm f/4 lens with Kodachrome 200 film and was holding it in my hands, wondering what to do next. Looking out of the car window I saw a group of wild dogs chasing a wildebeest, away behind the car. I hung out of the window to take a look through the lens, and at that moment the animal changed direction and came directly towards the car. I fired off about thirty shots hand held, from an ideal camera position. This time everything had fallen into place: I had a full roll of film; the zone of focus was exactly right and the autofocus worked perfectly, even though the animals were approaching at top speed. You can get an idea of the speed by looking at the animals' legs. Of the twelve legs, only three are touching the ground!

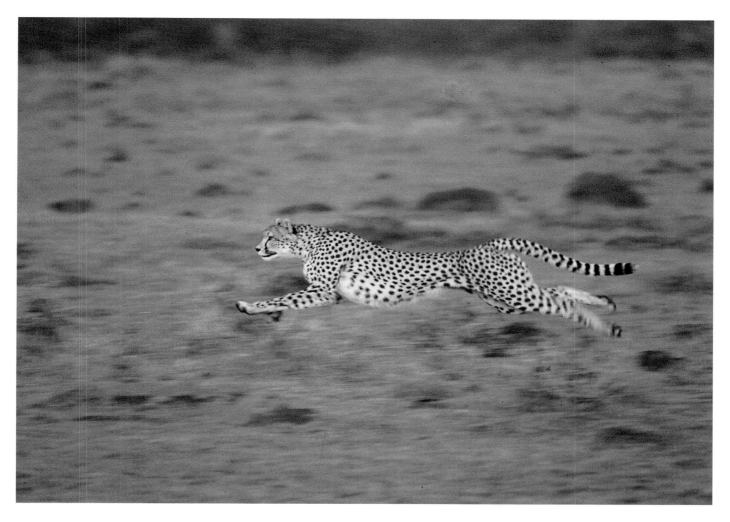

Hunting cheetah in full stride, Masai Mara, Kenya. 300mm f/4 lens, Fujichrome Velvia 50, car window support.

Cheetah in flight

Panning the camera to follow a moving subject is a technique that gives a strong impression of motion to the image. It has become second nature to sports photographers, especially in motor racing; it was probably the great photographer Ernst Haas who introduced the idea in nature photography. The cheetah is the fastest creature on four legs, at least over short distances, and this called for a small amount of blur to convey a sense of rapid motion. This wasn't easy to achieve. I spent six weeks along with the well-known nature photographer Norbert Rosing photographing cheetahs, and in all that time there was only one opportunity to get this picture. The difficulty is not just the cheetah's speed, but its hunting technique. Cheetahs stalk their prey very slowly, then adopt a leisurely pace, and only at the very last moment do they go into the burst of lightning speed for which they are famous. This sequence may begin near your camera position only to end up several hundred metres away. But just once in a while things come out right. So eventually I got a successful image of the world's fastest cat in full flight.

Lynx and her young, game reserve, Bayerischer Wald National Park. It would almost be impossible to get such a shot in Germany in the wild. The photograph is like a winter fairy tale, but the truth is that the animals are watching the approach of the keeper with a bucket of dead chicks. 300mm f/4 lens, Kodachrome 64.

The same pair as in the previous shot. You can compose pictures in reserves so that they appear to be in the wild. In reality, the two lynxes are feeding on meat brought by an attendant. I chose my viewpoint to create a hint of mystery and to keep the meat out of sight. 400mm f/3.5 lens, Kodachrome 200.

To *learn something and become more proficient over time, is that not a joy? And when like-minded people gather and become friends, is that not also a joy?*

Confucius

Photographing captive animals

One can approach nature as photographic subject matter from different directions. Some place a tame animal on a red stool with a gold foil background, take a photograph, and suppose themselves to be putting over some sort of message. Others deliberately juxtapose different elements of nature to achieve some kind of graphic effect, without any connection with reality. Others, again, spend their time photographing nothing but animals' faces and parts of their anatomy: it is unimportant to them whether the subject is a truly wild animal, or in a zoo, or trained, or someone's pet. Speaking for myself, I want to photograph untouched nature insofar as that is still possible. It makes no sense for me to go into zoos or animal farms and reserves: I cannot find what I want there; I can only fake nature by choosing viewpoints that avoid fences, gates and buildings in the picture. For me this is not nature photography; it is bogus. Such photography, to my mind, corresponds to a hunter buying a rabbit from a shop instead of shooting it himself. The idea of being a hunter is to hunt, and the idea of being a nature photographer is to photograph nature. Animals in zoos and safari parks are no longer in the wild. Their behaviour no longer matches that of a free animal, and their environment lacks authenticity.

So should we completely ignore photography in these controlled circumstances? Not necessarily, since there is another important consideration: many

Left: Helicon butterfly on plant in a butterfly garden. 200mm f4 macro lens and tripod.

animals can be photographed successfully only in captivity, because they are either too rare or too secretive in the wild. The lynx and wild cat, for example, are creatures I have never seen in the wild in Europe, although they certainly exist there. There are also some species which there is almost no chance to see anywhere, no matter how much one tries. For example, there are hardly any good photographs of a snow leopard taken in its natural habitat. There are three zoos in Germany and some twenty in the USA where there are snow leopards being bred, and if you want a

photograph of one, that is where you will have to go.

Even more misleading than zoos and reserves as far as animal behaviour is concerned are the game farms that are proliferating like mushrooms in the USA. Here you can rent the animals and their trainers by the hour. You want to photograph a lynx chasing a snow hare? No problem. One trainer holds the hare and another the lynx, When you are ready, both are released, and off you go. By the third hare or so, you will have captured a sensational picture. No doubt you will have

seen some of these phoney pictures. At these farms you can even photograph cougars and tigers coming directly towards you as you lie on the ground to add drama to the shot. You want snow leopards in the 'Himalayas'? No expense spared. They will fly a trained snow leopard into the Rocky Mountains for you and stage any situation you fancy. I am not making this up: these are regular offerings in American photo magazines.

We would all like to photograph nature untouched, but if this isn't possible, we would still like to photograph Nature's

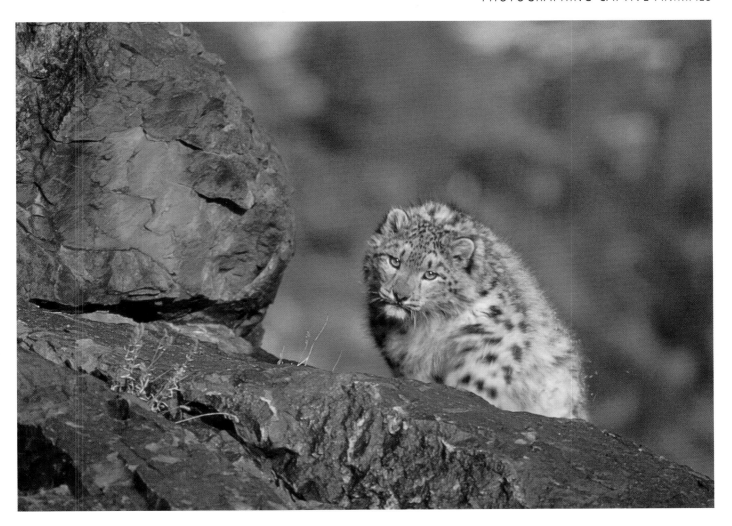

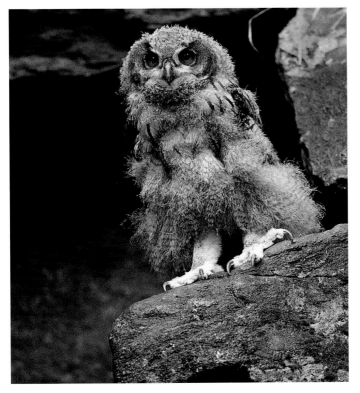

Above: Snow Leopard, Altai Mountains, Mongolia. Only a few westerners have ever seen a snow leopard. There are not many photographs that have been taken of this elusive cat in the wild. Nikon F4, 80-200mm zoom lens, Fujichrome Sensia 100.

Left: Young eagle owl in the game reserve, Bayerischer Wald National Park. 400mm f/3.5 lens, Kodachrome 200.

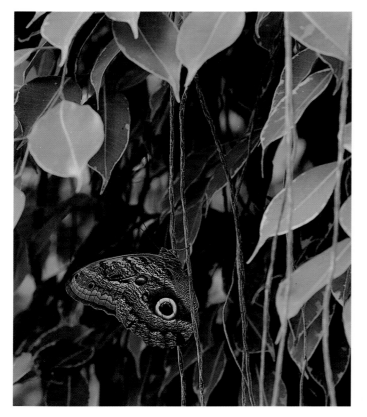

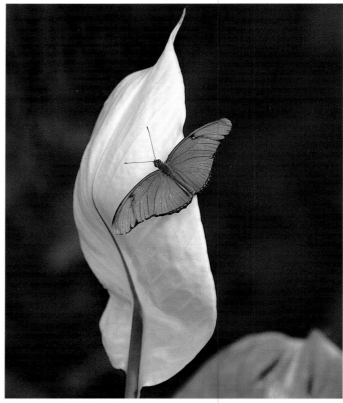

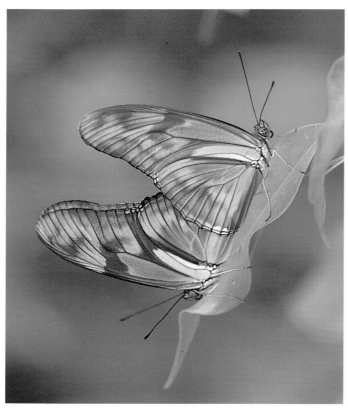

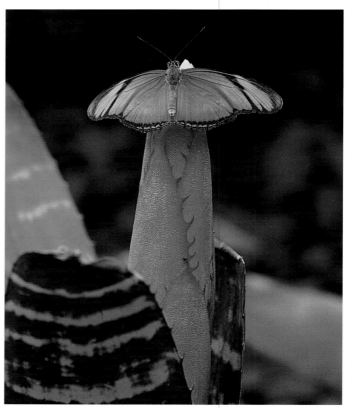

Images from the butterfly garden in Hamm.
All were taken with a 200mm f/4 macro lens
and tripod. The butterflies are a helicon and
an owl butterfly, both from Central and
South America.

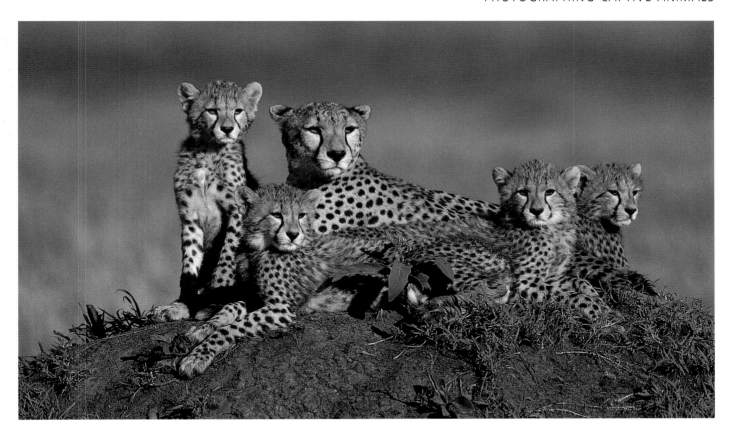

creatures. According to Hans Reinhard, a day without photography is a day lost. It is arguable that a photograph taken in a safari park or a butterfly farm is better than none at all. In fact, such controlled settings present advantages to the beginner. A butterfly can give you the opportunity to try out new lenses, tripods and cameras under working conditions, or to test new films. You can play with composition and the rule of thirds; you can practice zone focusing. You can check the effect of mirror slap. You can hone your flash technique and practice background composition with different macro lenses. But if you want to publish any of your shots, be honest. Say when and where you took them. If you don't, and some knowledgeable person spots a South American butterfly sitting on an Asian plant, your name will be mud in both the photographers' and the naturalists' worlds.

Amateur or professional?

The term 'amateur' means 'lover' or 'enthusiast', not 'beginner'. The amateur photographer practices nature photography out of love; the professional, on the other hand, must make a living out of it. Somewhere in between comes the

semi-pro who sells his or her work but retains a daytime job. Many people love nature photography, and indulge in it whenever they can. They give lectures on their work, sell images to agencies when they can, and perhaps drive a cab to support their photographic activities. If you are in full-time employment you should seriously consider whether it might not be better to pursue nature photography as a hobby rather than having to earn a living from it. You have 52 free Saturdays and 52 free Sundays, several weeks' annual holiday and seven or more public holidays every year in which to indulge your passion for nature photography. And your regular employment provides health insurance and pension contributions. None of this would be part of a full-time freelance career in photography. The amateur with a nine-to-five job can meet financial obligations and still have plenty of spare time in which to go on photographic safaris.

Nature photography is often seen as a fashionable occupation associated with the great outdoors and adventure, flying from one animal paradise to another all over the world, under contract to major publications. There are in fact very few photographers who can claim a lifestyle even close to this. If you want to be a

Above: A family of cheetahs photographed in the Masai Mara, Kenya. Although living in the wild the cheetah can become very trusting of humans as seen in the picture below!

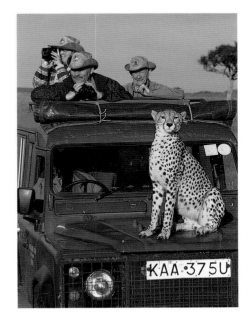

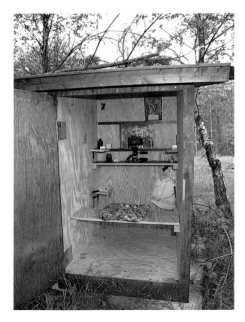

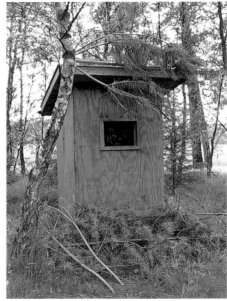

Permanent winter hide, shown here without camouflage.

nature photographer, it is more realistic to support yourself with a full-time job, and to gather your experience on the side. You may eventually want to go full-time – but your results will be matched against those who are already established.

The professional nature photographer who exposes a thousand rolls of film a year and spends eight or more hours a day studying subject matter has a much better opportunity for creating first-class images than the amateur. But the amateur has one big advantage: to be able to photograph in any way he or she likes, without the worries of 'will it sell?' or 'is it exactly what the agency wants?'

Regardless of whether or not you are a professional, the moment you submit an image for publication there are certain procedures you must follow. First, label your images clearly. You need the name of the animal or plant in English and Latin (and in your own language if this is not English), also the location and date of the photograph. Be quite specific with the location, especially with landscapes. List the camera, lens and film you used, and give details of exposure if possible. Be sure to include a note if the image was not made under natural conditions. This is particularly important for wildlife shots, because photo editors don't want to look foolish and readers have a right to know. For shots taken in zoos and wildlife reserves the standard phraseology is 'Photographed in controlled conditions'.

The finished hide. When not photographing, one should put a dummy lens hood, over the bottom of a bottle into the camera opening.

The animals will then not notice when a real lens is substituted. A bird bath in front of the hide makes it useful during the summer season.

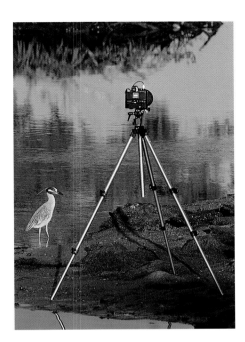

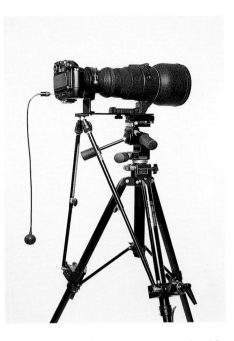

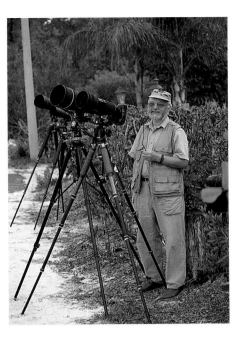

Above and centre: Since I wanted to use both cameras at the same time and, therefore, was not able to support the tripod camera to reduce the camera shake created by a 5fps motor drive, I turned the tripod into a 'pentapod'. Such additional supports are available from Manfrotto.

Above right: A 35-hour working week with six weeks of vacation and seven or more public holidays does not exist for the professional. But one should once in a blue moon take a ten-minute break.

Below: I was travelling with the well-known nature photographer Jurgen Weber in the Harz Mountains, to photograph capercaillies during courtship. While taking a break in the fog and rain, a cock appeared and pranced in front of Jurgen. Needless to say, the following day, when the sun was shining brightly, we did not see a single one.

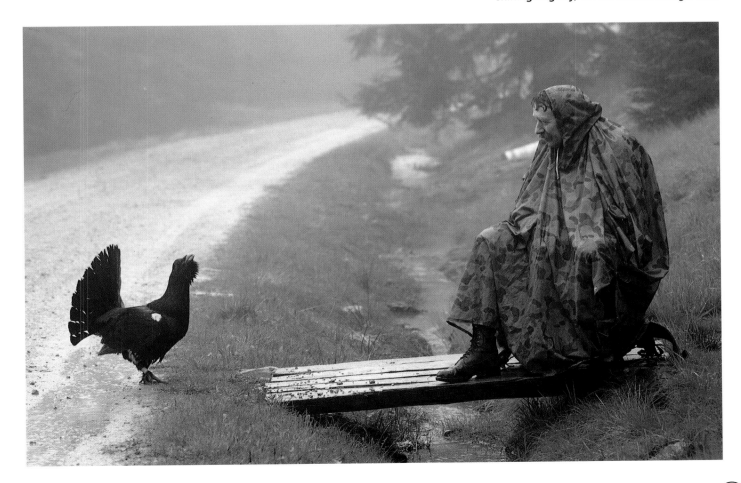

The ability to document, to witness and to describe events with a camera has given photography a unique advantage over other art forms. It depicts truth.

Martha Hill

Ethics of nature photography

Consider for a moment two proposed pictures. In the first a kingfisher sits on a tree trunk rising from a river bank, a fish in its beak. It is surrounded by seven little kingfishers, all looking expectantly at their mother. Eight reflections appear in the dark water. In the second, a female snow leopard reclines on an old gnarled tree with the snow-covered Himalayas behind her. On a branch next to her are her two small cubs.

If these were paintings, such scenes would leave me cold. I would know they were figments of the painter's imagination. But as photographs taken honestly in nature they would be sensational. I was deeply impressed the first time I saw a photograph of a lynx chasing a hare in deep snow with only about a metre between them. Now that I know these pictures are made in animal farms using a tame lynx I am no longer impressed. Instead I feel vaguely cheated, and depressed that such images should be made. There has, indeed, always been occasional distortion of the truth by some unscrupulous animal photographers and editors (though never by the committed members of our community). There are also new techniques for cheating. At one time photographs of tame animals were used in montages with mountain backgrounds, hunters with guns and the like. Such photomontages regularly appeared in hunting magazines. They were laborious to produce and not very convincing. Now, with dozens of animal farms and the ability to digitise the original and manipulate it in a computer, the whole question of authenticity has moved into a new dimension. Through the digital process you can put together images of eight kingfishers or three snow leopards and put them into an appropriate setting without anyone's being able to detect that it is not an untouched image (except possibly a very knowledgeable naturalist). The apparent willingness of some photographers to use this technology means that photography itself is liable to lose its credibility. And a photograph that is

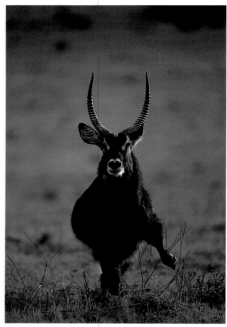

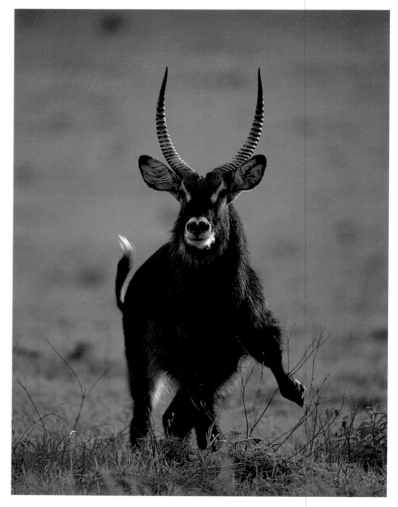

Water Buck. Digital manipulation has combined the best aspects of the top two photographs into the image above.

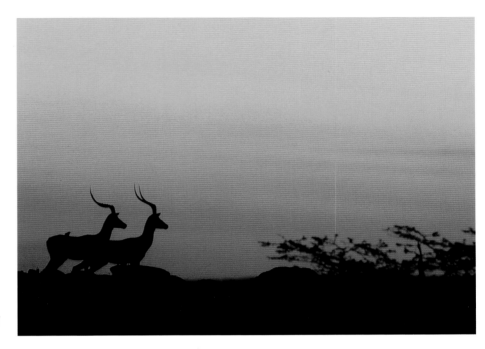

Two gazelles silhouetted against a beautiful sunset sky.

not credible is of no interest as a photograph. It is no more a true record than an animal painting is.

The powerful effect of a genuine nature photograph, which cannot be achieved with any other medium, comes from the depiction of reality. If we take away its veracity it becomes meaningless. It is thus important that all nature photographers clearly state whether their images are originals, or digitised compositions, or whether they were made using captive or tame animals under controlled conditions. The same goes for publications using nature images. These new forms of image could lower their status and challenge their traditions. Wildlife magazines thrive largely because their readers believe that what they see on the pages is genuine.

As an example of the way digital image manipulation can be used (comparatively innocently in this case), look at the shot of the water buck in the Ngorongoro Crater. In the top left picture the position of the ears and horns is good; the tail and leg position are fine, too. The top right image, though, has some flaws: one ear is partly hidden, the leg position is poor and there is no visible tail. On the other hand, the raised left leg is interesting. These two images were scanned and digitised, then assembled into the third picture, taking the best of both images. I am certain that editors of nature magazines and books would reject digitised compositions such as this because they know that such a

practice is harmful to nature photography, and therefore to themselves, were they to publish such artificial imagery. I am convinced that in the future we shall see a much stronger call for true nature documentation.

Truth in Nature Photography

Nature photography is a document which testifies and describes – and nature photography is truth, it is the unities of place, time and action in nature.

That alone is why it succeeded in setting out on this unprecedented triumphant advance reducing painting and drawing in the description of nature to insignificance. 99.9% of all nature depictions in books, journals and magazines today are photographs.

People still have confidence in nature photography. We shouldn't destroy this confidence by allowing it to become incredible because the viewer can no longer be sure that what is depicted in the journal or book in front of him does show the reality and truth or whether it is nothing but a recreated, improved or engineered kind of nature, or a sandwich, a montage - no matter whether by digital means, by two exposures on one negative or any other technique.

The viewer of a picture is entitled to be informed exactly as to whether the picture in front of him is a nature photographic-journalistic work, a stilted one recreating

nature with tame animals or a composition (or digital photomontage) derived from the artist's/photographer's fantasy showing something that never existed as such in reality. Thus not reflecting the unities of time, place and action as in the genuine, unengineered nature, but a fairy tale.

Therefore it might be quite a good idea if we set a good example, so to speak, and in the future always labelled our slides showing exactly how the picture in question is to be classified:

(authentic wild) for slides having been taken in the wild without any intervention on the part of the photographer.

(controlled conditions) for all slides where the photographer intervened in a creative manner or had control of events or image portions. For example, when laying a dead hare so as to turn it into a 'nice' composition when later on the buzzard lands on this lure. Or at the winter feeding place where the nature photographer can decide on which branch or on which trunk the woodpecker is to land and whether the background is to be green or blue.

The same holds true for the whole range of 'improved' close-ups. Many pictures contained in calendars give me the feeling when looking at them that what the nature photographers are dishing up there are no real nature photographs, but compositions in which mushrooms are replanted, leaves arranged photogenically, and brooks cleared of 'interfering' twigs and branches.

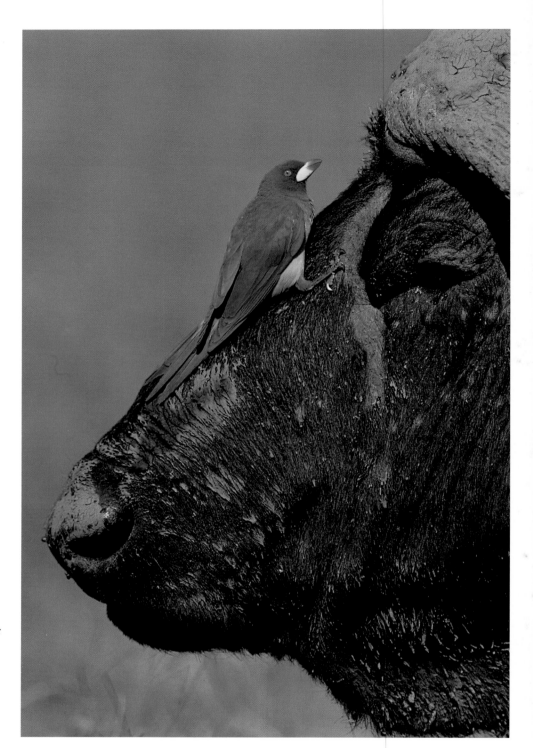

Yellow-billed oxpecker and cape buffalo in a symbiotic relationship. There are times when an event can only be communicated through a photograph. A tight composition which eliminates anything that might distract from its message. Masai Mara, Kenya, 600mm f/4 lens with X1.4 teleconverter, Fujichrome 100, car window support.

Opposite: Lilac-breasted roller, Masai Mara, Kenya. Nikon F4, 600mm f/4 lens, Fujichrome 100.

Thus these are often not photos showing us what nature looks like but pictures showing us what nature should look like if it were up to the photographer to decide. The viewer really has the right to know this.

This does, of course, also apply to photos taken of insects in so-called flight tunnels.

(authentic natural - not composed) for slides having been taken in the wild as close-up, without any composing or arranging on the motif or image.

(captive) All slides of tame or captured animals. This note is particularly important because in such case it would be a lot easier to correctly classify unnatural behaviour (Bart the bear!) or photos of behaviourally disturbed animals. Important

also with regard to photos of insects.

(photomontage) should be used as a comprehensive term for all kinds of montages regardless of whether double exposure (moon with cactus), sandwich (giraffe before sunset) or digital montage where branches are removed, animals added or out of several motifs a new one is created.

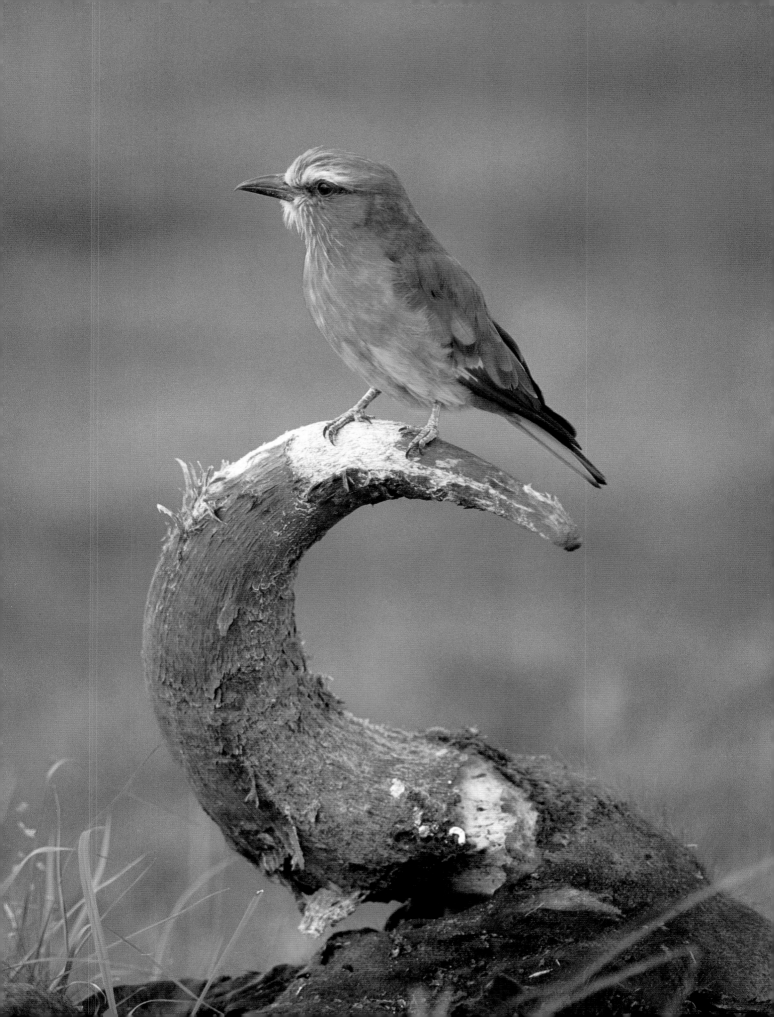

INDEX